Gino Severini From Futurism to Classicism

Exhibition tour

Estorick Collection of Modern
Italian Art, London
6 October 1999 – 9 January 2000

Ashmolean Museum of Art and
Archaeology, Oxford
18 January – 3 March 2000

Graves Art Gallery, Sheffield
11 March – 24 April 2000

...ational Touring Exhibitions

Published on the occasion of *Gino Severini: From Futurism to Classicism*,
a National Touring Exhibition organised by the Hayward Gallery, London,
for the Arts Council of England

Exhibition organised by Vicki Lewis, assisted by Sarah den Dicken, Claire Gott and Stuart Tulloch

Catalogue designed by Peter Campbell
Printed in England by The Beacon Press

Front cover: Gino Severini, *Self-Portrait*, 1916 (cat. 25)

Published by Hayward Gallery Publishing, London SE1 8XX
© The South Bank Centre 1999
Essays © the authors 1999
Works by Gino Severini © ADAGP, Paris and DACS, London 1999
Robert Delaunay, *Windows open simultaneously, first part, third motif*, 1912 © L & M SERVICES B.V. Amsterdam 990901
Fernand Léger, *Contrasting Forms*, 1913 © ADAGP, Paris and DACS, London 1999
Henri Matisse, *Piano Lesson*, 1916 © Succession H. Matisse / DACS 1999

Photographs:
cat. 17 © 1999 The Solomon R. Guggenheim Foundation, Photographer David Heald
cats. 9, 26, 36, 38 Antonio Maniscalco, Milan
p. 16 © 1999 The Museum of Modern Art, New York
p. 11 Photothèque des collections du Mnam/Cci – Centre Georges Pompidou
cat. 6 Photo VASARI, Rome
cat. 21 John Webb

ISBN 1 85332 199 0

This publication is distributed in North and South America and Canada by
the University of California Press, 2120 Berkeley Way, Berkeley, California 94720,
and elsewhere by Cornerhouse Publications.

Hayward Gallery Publishing titles are distributed outside North and South America
and Canada by Cornerhouse Publications, 70 Oxford Street, Manchester M1 5NH
(tel 0161 200 1503; fax 0161 200 1504; email: publications@cornerhouse.org).

Gino Severini's first solo exhibition was seen in London in 1913, at the Marlborough Gallery. Its reception – typical for a British audience at that time confronted by advanced art from the continent – ranged from adulation among the cognoscenti to bewildered reactions in the popular press. Since then he has been remarkably little shown in Britain.

Gino Severini: From Futurism to Classicism aims to redress this situation. The exhibition, the latest in an important strand of the National Touring Exhibitions programme, of focused presentations of work by masters of the twentieth century, highlights Severini's development during the most significant decade of his career. The years from 1910 to 1920 saw a profound shift in the artist's work and attitude, from Futurism, and its rhetoric of iconoclasm and modernity, through Cubism, to a style founded on the eternal laws of classicism. This passage is crucial to an understanding of Severini's highly distinctive art, and a fascinating parallel to the course pursued by many fellow artists of his generation, in Paris and beyond.

The exhibition and its concept were proposed by Martin Caiger-Smith, following discussion with Christopher Green; the initial inspiration for the project came from the important works of Severini from this decade held by the Estorick Collection of Modern Italian Art in London. We are delighted to collaborate, for the first time, with the Estorick Collection, where the exhibition will open, and pleased also that works from their collection, and the exhibition as a whole, are able to travel to a wider public, with two further showings outside London: the Ashmolean Museum in Oxford and the Graves Art Gallery in Sheffield. We thank Alexandra Noble at the Estorick Collection, Kate Eustace at the Ashmolean Museum and Anne Goodchild at the Graves Art Gallery for embracing the project with such enthusiasm.

The exhibition has been curated by Simonetta Fraquelli, with Christopher Green: we are grateful to them both for the expertise, diligence and flair that they have brought to the project, and for the illuminating essays they have contributed to the catalogue.

We are, in addition, enormously grateful to the owners of Severini's works, who have so generously lent to this show and given us every consideration. In particular, we should

like to thank the artist's daughters, Gina Severini Franchina and Romana Severini Brunori for their advice and support throughout.

Among those others who have shared their expert knowledge and helped us to realize this show are: Gabriella Belli, Anne Coffin Hanson, Massimo di Carlo, Roberta Cremocini, Claudia Dwek, Matthijs Erdman, Volker Feierabend, Dr Maria Teresa Fiorio, Daniela Fonti, Alessandra Franchina, Jennifer Franchina, Elena Geuna, Gabriele Mazzotta, Marilyn McCully, Daniele Pescali Jnr., Amedeo Porro, Philip Rylands, Peter Sawbridge and Evelyn Weiss. We owe them all our thanks.

The catalogue has been handsomely designed by Peter Campbell, and its production overseen by Lise Connellan. I am grateful to them for their efforts, and also thank, in particular, Vicki Lewis, Exhibition Organiser at the Hayward, who has taken responsibility for organising the exhibition and its tour.

Gino Severini: From Futurism to Classicism opens in London as part of a nationwide Festival of Italian Culture, under the patronage of His Excellency the Italian Ambassador Dr Luigi Amaduzzi. We are proud to be able to participate in this celebration, and pleased also to launch the exhibition in this most fitting context.

Susan Ferleger Brades
Director, Hayward Gallery

Simonetta Fraquelli

Gino Severini's first solo exhibition opened at London's Marlborough Gallery on 7 April 1913, the artist's thirtieth birthday.[1] The opening began at midnight and was a social event of significant proportions. The exhibition included thirty Futurist paintings and drawings and lasted just over a month. In his autobiography, *The Life of a Painter*, Severini records that he was interviewed 'like a prime minister' and that all the newspapers and magazines reviewed the exhibition, publishing his paintings and portraits.[2] In an article in the *Daily Express* entitled 'Get Inside The Picture: Futurism As The Artist Sees It', Severini reaffirmed the tenets of the Futurist Technical Manifesto of 1910. He exalted the city as 'the violent affirmation of human activity' and stated that the spectacle of the sea and mountains no longer moved the Futurists, who preferred 'the tragedy and the lyricism of electric light, of motor cars, of locomotives and aeroplanes'. On a more personal note, he explained his own works: 'A picture will no longer be the faithful reproduction of a scene, enclosed in a window frame, but the realization of a complex view of life or of things that live in space. What I call the perception of an object in space is the result of the memory of the object itself, of the experience of our mind of that object in its different aspects.' The London exhibition was crucial for Severini. It represented his first significant break from Marinetti's Futurist 'governo centrale' in Milan, and gave him the opportunity to move away from the orthodox doctrine of the Futurists to establish a position of his own.

There has never been a museum exhibition devoted to the work of Severini in this country, though his paintings have been shown in the context of Futurist group exhibitions or thematic shows of twentieth-century Italian art.[3] *Gino Severini: From Futurism to Classicism* goes some way to address this omission. Drawing primarily on European collections, it focuses on the most important decade of Severini's career: the years from 1910 until 1920. It follows the development of his art from his Futurist works of the early 1910s, with their rejection of the past and their emphasis on dynamism and the modern world, to his adoption of a Synthetic Cubist style during the war years and finally to the timeless and mathematically composed still lifes and figures he painted from 1919 onwards.

1. Marlborough Gallery, 34 Duke Street, St James's, London, 7 April 1913, *The Futurist Painter Severini Exhibits His Latest Works*. The exhibition was accompanied by a catalogue with an Introduction and notes on the works by Severini.

2. Gino Severini, *The Life of a Painter: The Autobiography of Gino Severini*, translated by Jennifer Franchina, Princeton University Press, New Jersey, 1995. This is a translation of Gino Severini, *La vita di un pittore*, Feltrinelli, Milan, 1983. This book has two sections: *La vita di un pittore* (Severini's life to 1917) and *Tempo de L'Effort Moderne* (Severini's life, 1917–24). Early editions: *Tutta la vita di un pittore* (up to 1917), Garzanti, Milan, 1946; *La vita di un pittore* (up to 1917), Edizioni di Comunità, Milan, 1965; *Tempo de L'Effort Moderne: La vita di un pittore* (1917–24), Vallechi, Florence, 1968. All quotations in this essay are taken from the English version.

3. See *Futurism, 1972–73*, exhibition catalogue, Hatton Gallery, Newcastle upon Tyne, and Royal Scottish Academy, Edinburgh; and *Italian Art in the Twentieth Century*, 1989, exhibition catalogue (ed. Emily Braun), Royal Academy of Arts, London. There was an exhibition devoted to the work of Severini at the Grosvenor Gallery, London, 3–29 June 1969.

'The two cities to which I am most deeply attached are Cortona and Paris, by birth to the first, intellectually and spiritually to the second.' So opens Severini's autobiography. From the outset Severini was so keen to identify himself with the French capital, where he lived from 1906 until his death in 1966 (apart from ten years in Rome from 1935 to 1946), that he slightly underplays the importance of his formative years in Rome. Having been expelled from school in Cortona, Tuscany, in 1899, the fifteen-year-old Gino was accompanied to the Italian capital by his mother who had recognized his artistic talent. There, initially dogged by poverty and lack of work, Severini, who always made friends with ease, began to establish himself. In 1900 or 1901 he met Umberto Boccioni and, despite his later unease at some of Boccioni's more exuberant outbursts during their Futurist collaboration, the two remained very close friends until Boccioni's premature death in 1916. Boccioni was also responsible for introducing Severini to Giacomo Balla. Balla, slightly older than Severini and Boccioni, was to prove instrumental in their artistic careers. Through his informal teachings he introduced the younger artists to the latest developments in Post-Impressionist art, which he had seen recently in Paris, and to the art and theory of the Italian Divisionist painters, such as Gaetano Previati, Giovanni Segantini and Pellizza da Volpedo.

4. See Annie-Paule Quinsac, *La Peinture divisionniste italienne: Origines et premiers développements 1880–1895*, Editions Klincksieck, Paris, 1972 and *Divisionismo italiano*, 1990, exhibition catalogue (ed. Gabriella Belli), Palazzo delle Albere, Trento.

Divisionist theory, like Pointillism, drew on nineteenth-century scientific research into optics and the physics of light.[4] Two colours juxtaposed (or 'divided') would fuse optically at a given distance, resulting in an increased luminosity and a heightened representation of natural light. The French Pointillists, Georges Seurat, Paul Signac and Henri Cross, relied primarily on the use of dots or 'points' of complementary colours to create controlled and ordered compositions, whereas the Italian Divisionists applied a combination of dots and fine straw-like parallel lines in a less organized yet more expressive manner. Severini and the other Futurists would adopt similar techniques in their attempt to evoke the sensory quality of the modern world. The Italian Divisionists differed from their French counterparts in their emphasis on individuality, in their focus on contemporary subject-matter and in their belief in the possibility of making art a total experience, similar to life itself. These ideas were fundamental to the Futurist doctrine: the Technical Manifesto of Futurist Painting, published in April 1910, stated unequivocally that 'painting cannot exist today without Divisionism'.[5]

5. Quoted in Umbro Apollonio (ed.), *Futurist Manifestos*, Thames and Hudson, London, 1973.

While in Rome, Severini also became acquainted with the writings of Nietzsche and Schopenhauer, Marx and Engels, and the Russian novelists Tolstoy, Dostoevsky and Gorky, among others. At the time, however, Rome was a provincial backwater in

comparison to Paris, and Severini's arrival in the French capital in October 1906, which he described so vividly in his autobiography – 'I was able to rejoice in the unforgettably grand surprise it offered' – must have been an extraordinary, if daunting, experience for the young artist.[6]

6. *The Life of a Painter*, 1995, p. 26.

By 1909, Severini had made Paris his home. Despite his continued poverty, Severini immersed himself in the frenetic cultural and artistic life that the city offered. He befriended his compatriot Amedeo Modigliani and, at the famous Le Lapin Agile café, engaged with other artists and poets, among them Suzanne Valadon, Maurice Utrillo, Juan Gris, Raoul Dufy, Max Jacob, André Salmon, Guillaume Apollinaire and, later, Pablo Picasso and Georges Braque. Between 1907 and 1908, Severini lived close to the Théâtre de l'Oeuvre, an experimental theatre run by Aurélian François Lugné-Poë, which acted as a meeting place for the literary avant-garde. It was at L'Oeuvre that Severini first encountered Filippo Tommaso Marinetti.[7] Though famous as the principal ideologue and promoter of Futurism, Marinetti had begun his career as a writer and Symbolist poet, founding the review *Poesia* in 1905. At the theatre Severini also met Felix Fénéon, who later introduced him to the Galerie Bernheim-Jeune where the first Futurist exhibition was held. At about the same time, Severini began to frequent the Closerie des Lilas, the café of the Symbolist poets and the literary review *Vers et Prose*, founded and directed by 'the Prince of Poets' Paul Fort, who was later to become Severini's father-in-law.

7. A friend of Lugné-Poë, Marinetti had recently been introduced to Boccioni in Milan. See Gino Severini, *Ecrits sur l'art*, edited by Serge Fauchereau, Diagonales, Editions Cercle d'Art, Paris, 1987, p. 33 (Lettre sur le Futurisme).

Severini produced little in these early years: his portraits and landscapes, influenced by the Post-Impressionism of Lucien Pissarro and Signac, are still tentative. In his autobiography he recalls how his admiration for Seurat and Pointillist theories dates from this

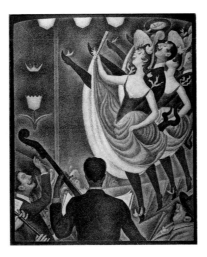

fig. 1
Georges Seurat
Chahut, 1889–90
oil on canvas, 171.5 x 140.5 cm
Collection Kröller-Müller Museum,
Otterlo, The Netherlands

8

8. *The Life of a Painter*, 1995, p. 95.

time: 'I looked to Seurat as my point of departure and my master'.[8] He greatly admired Seurat's use of complementary colours and the ordered nature of his compositions. These were often constructed on the principles of the Golden Section, on the proportion and relation of objects within the picture, the balance of verticals and horizontals, and on figures placed across the plane or at right angles to it (fig. 1). Though their static nature was opposed to the dynamism to which Severini later aspired in his Futurist paintings, the lessons of the French Neo-Impressionist master were to have a lasting influence on both his Futurist, and later his Cubist, work.

Marinetti's Futurist Manifesto of 1909 was a bold stroke. Published on 20 February 1909 on the front page of *Le Figaro*, the most influential newspaper in Paris, it instantly achieved its author's aim of reaching a mass audience. But curiously it had little effect on Severini. The overt patriotism and aggression of this outburst, its attack on women, its celebration of war as 'sole hygiene of the world', may have disturbed Severini, who was of a more earnest and gentle nature. Certain elements, however, such as a violent rejection of the past, an exaltation of the new and the celebration of the city, the machine and the beauty of speed, would undoubtedly have appealed to him. When these ideas were developed in the Manifesto of Futurist Painters (eventually published in *Poesia* on 11 February 1910), and sent by Marinetti and Boccioni to Severini in Paris for his approval, he was only too pleased to add his name to the signatories.[9]

9. For a general discussion on Futurism see Angelo Bozzolla and Caroline Tisdall, *Futurism*, Thames and Hudson, London, 1977; and Apollonio, 1973, for complete texts of manifestos.

This first manifesto, signed by the Futurist painters Boccioni, Carlo Carrà, Luigi Russolo, Balla and Severini, was in reality only a rebellious rallying cry. Written by Boccioni, Carrà and Russolo and merely signed by Balla and Severini, its rhetoric bears the stamp of Marinetti. In fact, the manifesto gave little indication of its authors' artistic intentions or the methods they would adopt and, apart from stating that art should take its inspiration from the 'tangible miracles of contemporary life', it contained little indication of what a Futurist painting might look like. This question was addressed in the second manifesto, the Technical Manifesto of Futurist Painting, which was almost entirely written by Boccioni and published on 11 April 1910, only two months after the first manifesto. The key concept was that of 'universal dynamism'. In a world of constant flux the Futurists' aim was to render 'dynamic sensation' itself in the work of art. The manifesto incorporated the notion of the 'superman' and the 'will to power' of Nietzsche, the idea of *élan vital* of Bergson, together with the evocations of Symbolism and recent scientific developments such as the X-ray. It was, however, its insistence on the phenomena of speed, the machine and city life that provided a blueprint for the five artists' work over the next two

years. During this period, Severini acted as a sort of foreign correspondent for the Futurists back in Italy. He kept them informed of the latest artistic developments in Paris and, worried by the provincial nature of their work, even insisted that they visited the French capital late in 1911 – before presenting their works to a Parisian audience.

Severini showed eight paintings in the Futurist exhibition held at the Galerie Bernheim-Jeune, Paris, in February 1912.[10] These works show Severini grappling with the tenets laid out in the Technical Manifesto. Although the manifesto had advocated that the dynamism of city life should be celebrated through the depiction of riots, uprisings or similarly explosive situations, Severini chose to represent the joyful spectacle of Parisian life: the café concerts, the boulevards, the famous dance halls and cabarets. His work developed naturally out of the experience of several years spent in Paris; in comparison to the other Futurists at the time, he was less subject to sudden changes of direction or hasty assimilation.[11]

Memories of a Journey, 1910–11 (cat. 1), is one of the eight paintings that Severini exhibited. He referred to this work often and explained: 'I had envisaged extending the horizons of plastic emotions to infinity, by destroying the unity between time and space with a picture of memories reuniting in a single plastic ensemble realities perceived in Tuscany, on the Alps, in Paris, etc.'[12] The painting records sensations experienced by the artist en route from his birthplace, Cortona, to Paris. In his attempt to illustrate simultaneity and the tricks played by memory, Severini created an evocative composition that swirls around the central image of an Italian well; the single viewpoint is abandoned and replaced with a cascading mass of objects and figures. A distinctive style emerged in this work through his use of blocks of dots or lines in different tones of the same colour which, unlike those of Divisionism or Pointillism, were not reliant on complementary colours. The objects or figures are not fragmented as they are in the paintings of Picasso or Braque; they abut each other with their elaborate clusters of colour-dabs in a manner reminiscent of Robert Delaunay's Cubist images of the Eiffel Tower.

In *The Boulevard*, 1910–11 (cat. 2), Severini implies a sense of movement by an ingenious use of shifting viewpoints and vibrating and vibrant colour. Unlike *Memories of a Journey*, the composition is constructed around an arrangement of coloured triangles and the inclusion of certain recognizable figurative details, such as the men's bowler hats and the branches on the trees. Quintessentially a Parisian subject, *The Boulevard* recalls Pissarro's series of views looking up the Avenue de l'Opéra of 1899, which Severini may well have

10. Galerie Bernheim-Jeune, Paris, 5–24 February 1912, *Les Peintres futuristes italiens* (group show; Severini's works were nos. 28–35). The exhibition travelled to more than fifteen venues, sometimes in an abbreviated form.

11. *The Life of a Painter*, 1995, pp. 86–88. Severini describes the other Futurists' visit to Paris and the subsequent changes in their work. See also *Boccioni*, 1988, exhibition catalogue (Ester Coen), Metropolitan Museum of Art, New York.

12. *Ecrits sur l'art*, 1987, p. 40 (Les analogies plastiques dans le dynamisme. Manifeste futuriste). For a review of the dating of this work, see Daniela Fonti, *Gino Severini: Catalogo ragionato*, Arnoldo Mondadori, Milan, 1988.

13. Severini saw Impressionist works at the Musée du Luxembourg in 1906 and there were several exhibitions of Pissarro at the Galerie Durand Ruel and the Galerie Bernheim-Jeune in Paris between 1908 and 1910.

14. The first to suggest this was Marianne W. Martin, *Futurist Art and Theory, 1909–1915*, Clarendon Press, Oxford, 1968, p. 96.

15. For a fuller discussion on Jules Romains, see Piero Pacini, 'Gino Severini: L'Unanimismo di Jules Romains e le danze cromatiche di Loïc Fuller I' in *Antichità Viva*, 29, no. 6 (1990), pp. 44–53 and 'Gino Severini: L'Unanimismo di Jules Romains e le danze cromatiche di Loïc Fuller II' in *Antichità Viva*, 30, nos. 4–5 (1991), pp. 57–64.

16. The original painting of the Pan Pan was lost. Severini made a replica from photographs in 1959–60.

17. From the catalogue of *Exhibition of Works by The Italian Futurist Painters*, The Sackville Gallery, London, March 1912.

18. In *L'Instransigéant*, 7 February 1912, recounted in *The Life of a Painter*, 1995, p. 80. In an essay in *Le Petit Bleu*, 9 February 1912, Apollinaire also wrote that the *Pan Pan* was: 'the most animated work in which his colours that do not blend at all provide us with the impression of movement. This painting will teach our young painters to become more daring than they have been in the past.'

19. With Marinetti, Apollinaire was best man at Severini's wedding to Jeanne Fort on 28 August 1913.

20. *The Life of a Painter*, 1995, p. 37.

known.[13] It has often been pointed out that the rhythmic effect created in the painting can be seen as an illustration of an Unanimist poem by Jules Romains: 'Que'est-ce qui transfigure ainsi le boulevard / L'allure des passants n'est presque pas physique / Ce ne sont des mouvements, ce sont des rhythmes.'[14] Unanimism was a philosophy proposed by Romains in his collection of poems published in 1908 under the title *La vie unanime*. Characterized by humanitarian and social concerns, likely to have appealed to Severini, the poems celebrated the city, crowds and every aspect of modern life. Romains believed that all things were interconnected, sharing the same interior life and linked by an inexorable life force. Like Severini, Romains was particularly enamoured of Paris. [15]

Severini's love of Paris was evident in his most ambitious work of the period, *The Dance of the Pan Pan at the Monico*, 1911 (fig. 2).[16] The English edition of the Futurist exhibition catalogue described it as: 'Sensations of the bustle and hubbub created by the Tsiganes, the champagne-sodden crowd, the perverse dance of the professionals, the clashing colours and laughter of the famous night-tavern at Montmartre.' [17] Severini employs a multitude of coloured geometric fragments strewn across the picture surface to recreate not only the inebriated frenzy of the dance, but also the sounds of the music and the laughter of the crowd. The image, which aims to place 'the spectator in the centre of the image' as advocated by the Futurist Manifesto, contains a portrait of Severini looking slightly bemused and overwhelmed by the experience. To his delight, the painting was singled out for praise by Apollinaire in his review of the Bernheim-Jeune exhibition: '*The Dance of the Pan Pan at the Monico*, the most important work to come from a Futurist brush to date, deserves further closer examination.' [18]

Severini was a close friend of Apollinaire[19] and the fact that he had praised his work, despite criticizing the exhibition in general, must have been particularly significant for Severini. Severini was already regarding his Futurist collaborators with scepticism. Sometimes embarrassed by their flamboyant antics, he often thought them provincial. In *The Life of a Painter* he draws the distinction between Futurism conceived in Milan – which was based on Art Nouveau and the Divisionism of the Lombardy painters, Giovanni Segantini, Gaetano Previati and Cesare Tallone – and Montmartre Futurism – a descendant of Neo-Impressionism (Seurat and Signac) and the art of Vincent van Gogh, Edgar Degas and Henri de Toulouse-Lautrec.[20] Naturally, he identified with the latter. Severini shared the Futurists' criticism of the Cubists for their failure to represent motion and to deal with modern subject-matter, but equally he desired to be accepted by Paris' artistic community. His Futurist paintings and drawings consistently refer to French and

fig. 2
Gino Severini
The Dance of the Pan Pan at the Monico, 1911 (replica 1959–60)
oil on canvas, 280 x 400 cm
Collections Mnam/Cci – Centre Georges Pompidou
F 97a

often specifically Parisian imagery: the Nord-Sud metro which linked Montmartre to Montparnasse, for example, or the Eiffel Tower, or the Place Pigalle, together with numerous dance halls and night clubs. His painting *Plastic Rhythm of 14 July*, 1913 (cat. 9) alludes to a café called 14 Juillet in Montmartre, as well as referring to Bastille Day and republican festivities. This work was painted shortly before his marriage to Jeanne, the daughter of the poet Paul Fort, on 28 August 1913; the union established him within the Parisian artistic circle.

By the end of 1912 Severini had developed his own mature Futurist style. He had abandoned Divisionism, and the Futurist preoccupation with the depiction of speed – the great transformer of the sensory experience of modern man – had become overriding for him. In 1913 Severini wrote: 'Speed has given us a new notion of space and time and consequently of life itself. It follows therefore that the plastic arts of our time should be characterized by a stylization of speed.'[21] He went on to say that the aim was not to try to depict a speeding object but rather speed itself. Again, Severini chose a very different path to that of the other Futurists. Rather than aeroplanes, cars or trains, his preferred vehicle for expressing the sensation of universal dynamism was dance.[22] A talented dancer him-

21. See *Ecrits sur l'art*, 1987, p. 43 (Les analogies plastiques dans le dynamisme). For a discussion about the similarities between Severini's writings and the theories of Bergson, see *Severini Futurista 1912–1917*, 1995, exhibition catalogue (Anne Coffin Hanson), Yale University Art Gallery, New Haven, p. 36.

22. Severini's first passion when he arrived in Paris in 1906 had been flying, but this does not seem to have affected his choice of subject-matter.

self, he had been a regular visitor to the dance halls and nightclubs of Paris from about 1908. Like Degas, Severini can be considered a supreme painter of dancers; the theme of the dance, which remained a dominant feature of his work up to 1916 (see cat. 23, *Dancer*, 1915–16), was to resurface in his Futurist evocations of the late 1950s.

Severini's images of dancers are not determined by a pattern of movement that travels horizontally across the surface of the canvas as in some paintings by Boccioni or Carrà. Instead, his approach is to suggest movement emanating in a centrifugal manner from the figures themselves. In turn, through the fragmentation of the forms, the colours and the effects of light (sometimes rendered literal through the application of sequins to the surface of the painting), this movement is linked to objects and space around it. Though intent on showing motion, these paintings are reminiscent also of the centrally composed images of the Cubists. Severini's paintings go beyond the evocation of the dance. They attempt also through their rhythmic use of different forms (such as zigzag or wavy lines and rounded or pointed shapes) to recall different kinds of music – the polka, the foxtrot, the waltz or fashionable dances of the time like the Argentine tango or the bear dance (see cat. 6, *Spanish Dancer at the Tabarin*, 1912–13; cat. 4, *The Bear Dance*, 1912; cat. 5, *The Bear Dance*, 1913).

23. From Marinetti's Technical Manifesto of Futurist Literature, published 11 May 1912. See Hanson, 1995, p. 45.

24. These texts were not published until the 1950s. See *Ecrits sur l'art*, 1987, pp. 39–52.

25. Soon after his wedding, Severini and his wife left for Italy. They did not return to Paris until a year later, in October 1914. During this period he was in contact with Balla who was also experimenting with abstraction at the time and who may have reinforced his choices.

Dance was the inspiration behind a series of works that Severini painted between 1913 and 1914, which he later referred to as 'plastic analogies'. Understanding it as a literary term, Marinetti had described analogy as 'no more than the deep love that unites distant, diverse and seemingly hostile things'.[23] Severini equated the destruction of perspective in the visual arts with Marinetti's destruction of syntax in literature. In two texts of 1913, *Les Analogies plastiques dans le dynamisme* and *L'Art du fantastique dans le sacré*, Severini explained the notion of analogies in his paintings. He wrote: 'spiral forms and contrasts of yellow and blue discovered by our intuition one evening while experiencing the action of a dancer, can be found later on, either through their affinity or their contrast, in a spiral flight of a plane or in the shimmering surface of the sea.' Particular forms and colours would be used to express the sensations of noise, sounds, smells, light, heat and speed.[24] In order to convey these analogies, as for example in his *Sea = Dancer*, 1914 (cat. 17), Severini dissolved the figurative elements of the dancer into abstract geometric forms made of colour-light dots, which contract or expand depending on the intensity of the colours.[25] He had explained this evolution in his art in 1913 when he wrote: 'the need for abstraction and for symbols is a characteristic sign of that intensity and rapidity with which life is lived today … Things possess neither integral form nor individual outlines.

Our perception bestows on objects boundaries in space, and these boundaries are the outcome, of the multiple influences of remembrance, of ambience and emotion.'[26]

26. From Introduction to *The Futurist Painter Severini Exhibits His Latest Works*, 7 April 1913, exhibition catalogue, Marlborough Gallery, 34 Duke Street, St James's, London, p. 3.

By 1914 the Futurist group was beginning to disintegrate, with each member, including Severini, forging a particular path of his own. Marinetti's last successful attempt to rally them came with the outbreak of war in August of that year. The Futurists, who had celebrated the notion of war from the outset, often participated in the demonstrations in support of Italy's intervention in the conflict. In November 1914, Marinetti wrote to Severini in Paris: 'what we need is not only direct collaboration in the splendour of this conflagration, but also the plastic expression of the Futurist hour. We urge you to interest yourself pictorially in the war and its repercussions in Paris. Try to live the war pictorially, studying it in all its mechanical forms (military trains, fortifications, wounded men, ambulances, hospitals, parades, etc.)'[27] All the Futurist artists responded to Marinetti in some way or another, but perhaps Severini, the least aggressive and most retiring of them all, came closest to being the Futurist artist of war that Marinetti had so desired.

27. Letter of 20 November 1914, quoted in Bozzolla and Tisdall, 1977, p. 190.

There are several possible reasons for this. Severini, though Italian, had chosen to return to Paris from Italy at the outbreak of war. However, his allegiance to his homeland, together with his desire to be accepted in his adopted country and perhaps frustration or guilt at being a non-combatant (owing to his persistent ill-health), caused him to immerse himself in his work.[28] It has been pointed out that Severini's interest in the theme of war was probably also aroused by a war poem written by Paul Fort which alluded to the catastrophic bombing of Reims Cathedral in September 1914.[29] In *Cannon in Action*, 1914–15 (cat. 19), the artilleryman in the trenches is dwarfed by the presence of the huge weapon. Sensory descriptions, 'noise-light, vibrations, shuddering and rustling', radiate like lines of forces, conveying the interaction of the cannon with its surroundings. With its patriotic reference to France as 'arithmetical / perfection / geometrical / rhythm / POWER / LIGHTNESS / FRANCE', Severini makes his allegiance clear.

28. Many of his French artist friends had enlisted, as had the other Futurists who joined the Lombard Volunteer Cyclist Battalion as soon as Italy entered the War in 1915. For a fuller discussion on the reaction of artists in Paris to the War, see Kenneth Silver, *Esprit de Corps, The Art of the Parisian Avant-garde and the First World War*, Princeton University Press, New Jersey, 1989.

29. See Bozzolla and Tisdall, 1977, p. 190, and Hanson, 1995, p. 104.

In *The Life of a Painter*, Severini wrote that at Igny, a rural suburb south-east of Paris where he and his family spent the summer of 1915, 'Freight trains carrying war supplies passed by the windows day and night. Others transported soldiers and the wounded. I did several paintings of them, the so-called war pictures. Although my inspiration derived from those real objects that passed before my eyes, these became more and more synthetic and symbolic, to the point of becoming, in the paintings made the following winter, true "symbols of war".'[30] In *The Hospital Train*, 1915 (cat. 20), the symbols of the tricolour,

30. *The Life of a Painter*, 1995, p. 156.

the Red Cross flag, the railway signs, the rooftops and the lettering from *Le Figaro*, are rendered through overlapping and interpenetrating planes reminiscent of the static Cubist compositions of Picasso and Braque. The sense of dynamism is not evoked through the speed of the train; instead, it is achieved through the viewer's simultaneous assimilation of Severini's 'symbols' of war.

Driven in part by his desperate need for money, Severini organized an exhibition of his war pictures at the small and little-known Galerie Boutet de Monvel in January 1916.[31] The show represented his last Futurist statement; by the end of the year his ideas and art had moved away from the Futurist concerns of movement and simultaneity which had pre-occupied him since 1910. In an engaging *Self-Portrait*, 1916 (cat. 25), which is related to a naturalistic self-portrait (cat. 26), Severini confronts the viewer with one realistic and one schematic eye, as if his features were somehow being changed into a new Cubist structure.

In the small print of *The Dressmaker*, 1916 (cat. 24), the figure of the dressmaker is constructed with a series of flat cut-out geometric shapes with bold outlines. Severini used the print ingeniously to create a visual pun: for just as the dressmaker is cutting out the pattern of the dress, so the figure of the dressmaker is 'cut out' of the linocut.[32] Severini must have attached a certain importance to this print, as a version was included in the exhibition of his work held at Alfred Stieglitz's New York gallery, 291, in 1917.[33] The exhibition included paintings and drawings that had been completed before October 1916 (the shipping date to New York) and although most of these were Futurist in style, some were unashamedly Cubist. In the preface to the exhibition, Severini defended this seeming about-turn by proposing a reconciliation between the opposing tendencies of Futurism and Cubism. Cubism, he said, is a 'Reaction to Impressionism' but Futurism is the 'Continuation of Impressionism'. 'The first claimed Ingres, the second Delacroix … if Cubism represents will or reason, then Futurism represented sensibility or emotion.' He concluded: 'as in all epochs the work of art today must be made up of these two elements.'[34]

The year 1916 was a turning point for Severini. The war seemed interminable: Severini, in Paris, was cut off from his Futurist friends, and he suffered the personal tragedies of the deaths of his infant son, Tonio, and that of his friend and collaborator, Boccioni (who died in a freak riding accident). His paintings of his family – the *Portrait of Jeanne*, 1916 (fig. 3) and *Motherhood*, 1916 (fig. 4) – are often interpreted as precursors of the 'call-to-order', which gathered force in the next few years. They also testify to Severini's adhesion to the trend towards classicism prevalent in Paris at that time, as in the Ingres-like

31. *1re Exposition Futuriste d'Art Plastique de la Guerre et d'autres oeuvres antérieures*, 15 January– 1 February 1916, Galerie Boutet de Monvel, 18 rue Tronchet, VIII arrondissement.

32. An edition of three, it was originally published in the September–October issue of the literary review *S.I.C.* in 1916. See Joan Lukach, 'Severini's Writings and Paintings, 1916–1917, and His Exhibition in New York City' in *Critica d'Arte*, 138, November– December 1974, pp. 59–80.

33. For the most thorough discussion of Severini's New York exhibition in 1917, see Hanson, 1995.

34. Quoted in Hanson, 1995, p. 127.

fig. 3
Gino Severini
Portrait of Jeanne, 1916
oil on canvas, 46 x 38 cm
Private Collection (courtesy Galleria
dello Scudo, Verona)
F 279

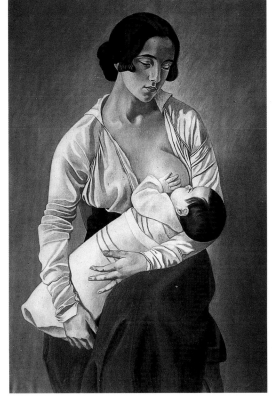

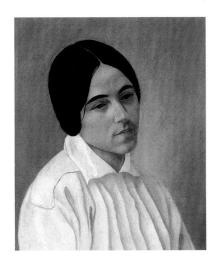

fig. 4
Gino Severini
Motherhood, 1916
oil on canvas, 92 x 65 cm
Museo dell'Accademia Etrusca di
Cortona
F 276

portraits of Picasso. In his autobiography, Severini referred to these works as 'close to the Tuscan primitive painters'. This is interesting in relation to his later figurative work of the 1920s (when he adopted fresco techniques and claimed allegiance to the Quattrocento notion of 'mestiere', or craftmanship) and in regard to his figures which were not painted from the models but instead were rigidly structured in the space rather like in a Piero della Francesca painting, or, indeed, in a Cubist painting.[35] It seems, however, that, above all, these intimate images of himself and his family represent a moment of personal reflection in the artist's mind.

Severini justified the change of direction in his work in his article 'Symbolisme plastique et symbolisme littéraire', published in the journal *Mercure de France* in February 1916.[36] In this he stressed how science had changed modern man's perception. This new scientific philosophy called for a correspondingly new aesthetic, one that drew on both sensation and reason. In order to represent an object and its relation with its surroundings, Severini no longer advocated a form of abstraction where the objects were dematerialized as he

35. Fonti, 1988, p. 240.

36. *Ecrits sur l'art*, 1987, pp. 61–70. The article was based on a lecture he had given at the opening of his Galerie Boutet de Monvel exhibition, entitled 'Avant-garde Plastic Art and Modern Science' and divided into three parts: (i) The physical origin of aesthetic emotion; (ii) Fragmentary, ultra rapid and prismatic life, the environment of perception; (iii) Plastic analogies, plastic synthesis of ideas, new plastic symbolism. Severini also published a second article, 'La peinture d'avant-garde, Le Mechanisme de l'art — Reconstruction de l'Univers' in the same journal in the following year (see *Ecrits sur l'art*, 1987, pp. 79–95), in which he focused on the scientific philosophy and forces of reason in art.

37. See *Ecrits sur l'art*, 1987, pp. 88–91 (La Peinture d'avant-garde, Le Mechanisme de l'art – Reconstruction de l'Univers).

had done in 1913. From now on, Severini would make use of mathematics and geometry to construct his images.[37] In a manner similar to that of Juan Gris in his Synthetic Cubist paintings of the same years, Severini would order fragmented geometric forms according to a preconceived pictorial structure. The forms used would be governed by those inherent in the object itself. In contrast to that of his Futurist paintings, Severini adopted the subject-matter of the Cubists: portraits, interiors and above all still lifes. Although the paintings of these years represent an overt stylistic and thematic renunciation of his Futurist works, in his writings Severini was keen to stress a certain continuity, in that he felt that 'static' or 'lifeless' objects were rendered no less dynamically than the moving objects previously depicted. In his autobiography, he wrote: 'I, uneasy and dissatisfied with myself, put aside my dancers and started painting static things, deeming it undignified to facilitate my work with "subjects". In other words, I was striving for a dynamic art capable of reaching its maximum potential, but I also wanted to express a universal dynamism using any random subject and using only pictorial means, that is, through the use of lines and colours arranged in a certain order.'[38]

38. *The Life of a Painter*, 1995, p. 165.

The emphasis on colour remained constant in Severini's painting. Seurat's scientific approach, together with his poetic or even metaphysical use of colour, had been an

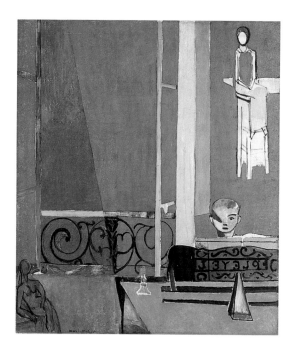

fig. 5
Henri Matisse
Piano Lesson, 1916
oil on canvas, 245.1 x 212.7 cm
The Museum of Modern Art, New York
Mrs Simon Guggenheim Fund

important model for Severini's early work and his particular brand of 'lyrical' Futurism. From 1916, however, Severini also looked to another French master, Henri Matisse, for inspiration: 'the better I knew Matisse,' he wrote, 'the more I appreciated him as an artist and as a man.'[39] Describing Matisse's paintings, he observed that 'instead of painting with little touches by opposing to each colour-touch another analogous or complementary colour-touch, he massed a quantity of red, for example, and then a quantity of green or of blue, etc., opposing one quantity to another quantity.'[40] The juxtaposition of colour, like the juxtaposition of geometric forms, could be used to reconstruct the pictorial object and to create a new 'sense of space'. The pink, green and blue in *Still Life with Bottle of Marsala*, 1917 (cat. 32), recall Matisse's blocks of colour in *Piano Lesson*, 1916 (fig. 5). In Severini's painting, as in several other of his works of 1916 and 1917, the brightly coloured blocks of geometric forms overlap or are elided to construct the still-life elements – the bottle, the glass, the book. In some works, such as *Still Life with Literary Review 'Nord-Sud' (Homage to Reverdy)*, c.1917 (cat. 33), he included lettering and collage elements (the playing card, the cover of the journal *Nord-Sud*) – a typical Cubist gambit, serving to emphasize the 'real' nature of the objects represented.

Severini spent the summer of 1917 in Civray, near Poitiers, where he painted his only Cubist landscapes.[41] The arrangement of the geometric forms in *Landscape: Civray*, 1917 (cat. 31), is similar to that of his contemporary still lifes, so much so that the church spire and surrounding houses which are so abstracted could be mistaken for an ensemble of still-life elements. Though characterized by a freshness and spontaneity, the repetitive nature of the works of these years suggest that Severini was working painstakingly to resolve his newly adopted aesthetic.

From 1918, Severini's approach to geometry in his works became increasingly rigorous: 'I thought that geometry and mathematics should be used more precisely, that artists should apply, and would benefit from, strictly observed laws of geometry and mathematics.'[42] In accordance with this, he preceded his paintings with a 'tracciato', a scale drawing in which the composition was calculated by a complex system of lateral and rotational symmetry, balance and corresponding chromatic harmonies (see cats. 35 and 36, *Gypsy Playing the Accordion*, 1919). These geometric compositions were based on strict numerical relationships that incorporated the concept of the fourth dimension: the unity of time and space. Some of these 'tracciati' functioned purely as working drawings, whereas others were more highly finished, as if Severini valued them independently (see cat. 38, *Study for 'Still Life with Fish'*, 1919). The Gypsy painting was shown in Severini's

39. *The Life of a Painter*, 1995, p. 170.

40. Quoted in Hanson, 1995, p. 128.

41. Severini stayed with the family of his friend Pierre Declide in Civray. Declide, a young dentist whom Severini met in 1908, had died shortly before.

42. *The Life of a Painter*, 1995, p. 210.

43. *The Life of a Painter*, 1995, pp. 184–185.

44. *The Life of a Painter*, 1995, p. 210.

45. See *Ecrits sur l'art*, 1987, pp. 323–324.

exhibition at Léonce Rosenberg's Galerie de l'Effort Moderne in 1919. Severini had signed a three-year contract with the dealer Rosenberg, cementing the agreement they had originally made in 1916 when Juan Gris had introduced them.[43] Highly autocratic, Rosenberg ran his gallery with an emphasis on the collective and an anti-individual policy. Severini entered his stable – which included among others Gris, Jean Metzinger and Henri Laurens – and subscribed, if reluctantly, to his demands and restrictions. He continued to develop his own ideas, reaching the conclusion by the end of the decade that it was in numbers that he 'glimpsed the path leading to the infinite, towards absolute purity, superhuman poetry and perfect harmony'.[44] The concept of 'universal dynamism' remained, but now it was to be achieved through a highly classical and ordered art; one which looked to the past, became increasingly figurative and brought Severini back to his Italian roots. His work of these years culminated with the publication of his treatise, *Du cubisme au classicisme*, in 1921.

In the preface to a small retrospective held at the Berggruen Gallery in Paris in 1956, Severini recalled the years of his youth in the French capital: he explained how the differences between Futurism and Cubism could be reconciled to provide a more poetic understanding of the works and that the Synthetic Cubism he practised aspired to the notion of the eternal and consequently to a form of classicism.[45] Notwithstanding the seeming contradictions of the trajectory of his art between 1910 and 1920 – contradictions that remained right up until his death in 1966 – Severini's artistic vision continues to touch both the senses and the intellect.

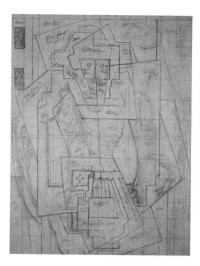

cat. 36
Study for 'Gypsy Playing the Accordion', 1919
pencil, charcoal and tempera on paper, 120 x 80 cm
Franchina Collection
F 366a

Border Crossings and Border Controls

Christopher Green

Severini's little panel picture, *Still Life with Bottle of Marsala* (cat. 32), was painted early in 1917, when combat troops and civilians in France could no longer imagine the Great War ending. He includes in it a book cover which alludes to Stendhal: a passing homage to a Frenchman long associated with Italy, from an Italian in France. Italy and France had been Great War allies for two years.

Severini's career in France was far from unique.[1] He arrived in 1906 with the beginnings of a reputation as an artist, already having supporters in Rome. Like many foreign artists, he quickly made friends with other new arrivals of his nationality (including Amedeo Modigliani), forming a little self-protective Italian group in Montmartre, but within a few years learned to move easily among the cosmopolitan circles of Montmartre and Montparnasse, making French friends and allies quickly.[2] Despite the growing xenophobia that, between 1911 and 1914, accompanied France's preparations for European war, the dominant ethos of the liberal Third Republic was outgoing, especially in the art world of Paris with its 'free academies' and their dependence on foreign students. Nationalist cultural propaganda may have been loud and, in the Quartier Latin, the Royalist fringe group 'Action française' may have given it thuggish force, but for the liberal Republicans who formed the vast majority, the strength of French culture was demonstrated by its capacity to assimilate the foreign: to make the Modiglianis and Severinis French.[3] With the approach of war, poor health prevented both Modigliani and Severini from volunteering for the foreign legion; Italy did not enter the war until May 1915. They would have understood, however, the declaration of loyalty to France published in the French press on 29 July 1914 by their fellow Paris-based Italian, the writer Ricciotto Canudo, and the Swiss poet Blaise Cendrars: 'Foreigners, friends of France, who … have learned to love and cherish her like a second fatherland, feel the imperative need to offer themselves to her.'[4]

1. See Gino Severini, *The Life of a Painter: The Autobiography of Gino Severini*, translated by Jennifer Franchina, with an introduction by Anne Coffin Hanson, Princeton University Press, New Jersey, 1995. This is a translation of Gino Severini, *La vita di un pittore*, Feltrinelli, Milan, 1983. The book has two sections: *La vita di un pittore* (Severini's life to 1917) and *Tempo de L'Effort Moderne* (Severini's life, 1917–24). Early editions: *Tutta la vita di un pittore* (up to 1917), Garzanti, Milan, 1946; *La vita di un pittore* (up to 1917), Edizioni di Communità, Milan, 1965; *Tempo de L'Effort Moderne: La vita di un pittore* (1917–24), Vallechi, Florence, 1968. All quotations in this essay are taken from the English version.

2. Severini was based in Montmartre between 1906 and 1911, a period when it was a major artistic centre. He moved to Montparnasse in 1911, precisely as this fast expanding and modernizing district took over as the most important artistic centre in Paris. Though focused on the question of Jewish artists in Paris, an especially useful introduction to the role of these districts in the city's art worlds is Kenneth E. Silver and Romy Golan (eds.), *The Circle of Montparnasse: Jewish Artists in Paris 1905–1945*, exhibition catalogue, The Jewish Museum, New York, 1985.

3. 'Action française' was a political organization with a paramilitary wing (the Camelots du roi) and a newspaper. Its role in politicizing traditionalist culture in France, especially between 1911 and 1914, is explored in James D. Herbert, *Fauve Painting: The Making of Cultural Politics*, Yale University Press, New Haven and London, 1992; and in David Cottington, *Cubism in the Shadow of War: The Avant-Garde and Politics in Paris, 1905–1914*, Yale University Press, New Haven and London, 1976. These important studies play down, wrongly I believe, the persistence of a dominant ethos of assimilation in Third Republic France. For this, see Rogers Brubaker, *Citizenship and Nationhood in France and Germany*, M.I.T. Press, Cambridge, Mass. and London, 1992.

4. The statement appeared simultaneously in many newspapers. It is cited in Sylvain Lecombre, in collaboration with Helena Staub, *Ossip Zadkine: L'oeuvre sculpté*, Paris-Musées, Paris, 1994, p. 36.

Nevertheless, there is one factor that renders the case of Severini as a foreign artist in Paris distinct from the norm: his involvement with F.T. Marinetti and the Futurists. Marinetti approached international cultural relations in much the same way as the great European governments approached international diplomatic relations at that moment – using exhibitions and manifestos in single-minded pursuit of Futurist domination in Europe. When, therefore, Marinetti brought Futurism to Paris, Umberto Boccioni – the movement's leading painter-theorist who had been Severini's friend from his early days in Rome – cast the movement in the role of antagonist, confronting and challenging the Paris-based Cubists as leaders of the European avant-garde. The language of Boccioni's Preface to the catalogue of the exhibition of Futurist painting which Severini helped set up at the Galerie Bernheim-Jeune in February 1912, could not have been more brutally explicit. Having been successfully assimilated into the Parisian art worlds of Montmartre and Montparnasse, Severini attached himself to a movement which openly flaunted its foreign belligerence: he signed the Preface with the other exhibitors. It is hardly surprising that his experience of Futurism was itself characterized by conflict – a conflict which repeatedly set his identification with France against his need to continue to identify with Italy.

Severini's assimilation into French culture was conclusively confirmed on 28 August 1913 by his marriage to Jeanne, the teenage daughter of Paul Fort, Frenchman, poet and editor of *Vers et Prose*, a periodical at the very centre of literary modernism in Paris. Presiding over his 'Tuesdays' at the Closerie des Lilas café in Montparnasse, Fort's role at the centre of a constantly changing international intelligentsia was specifically to bring the French and the foreign together: 'It's the marriage of France and Italy,' he proclaimed at Severini's wedding.[5] Marinetti himself, whose involvement with Parisian literary circles went back many years, was well known at the Closerie, and indeed it was he who first took Severini there (probably late in 1911). Pointedly, however, Marinetti opposed the marriage to Jeanne with all his vigour, even threatening to withdraw Futurist 'solidarity' if Severini went through with it. Marinetti wanted Severini's uncompromising commitment to Futurism as an Italian movement. Such a threat was serious: it meant withdrawal of financial support.[6]

Severini tried hard to belong as a Futurist, especially between his visit to Milan in 1911 and the beginning of the war in 1914. He signed all the important joint manifestos, and he showed as a Futurist not only at Bernheim-Jeune, but in London, Berlin, Milan, Florence and Rome. Even as late as January 1916, increasingly out of touch with Marinetti in Italy,

5. *The Life of a Painter*, 1995, p. 126.

6. For Marinetti's opposition to the marriage, see ibid.

he called his solo exhibition at the Galerie Boutet de Monvel in Paris the 'First Futurist Exhibition of the Plastic Arts of the War'. In his autobiography, however, he repeatedly stresses his distance from Futurism and its Italian agendas. He distinguishes sharply between 'Futurism as conceived in Milan', and 'Futurism conceived in Montmartre' (his own); at another point, he writes of being 'pulled by opposite poles: Paris and Milan,' adding that 'I felt closer to my Parisian friends beside whom my career had begun.'[7]

7. Ibid. p. 37 and pp. 123–124.

It can seem that Severini's trajectory as a painter, between his engagement with the Futurists in 1910–11, and his move into openly Cubist idioms in 1916–17, with pictures such as *Still Life with Bottle of Marsala*, 1917 (cat. 32), carries him from Italy to France as he switches '-isms'. Striking contrasts can be made between the full-blooded Futurism of *Expansion of Light (Centrifugal and Centripetal)* (cat. 15) or of *Sea = Dancer* (cat. 17), both painted at Anzio, where Severini was convalescing from lung disease during his extended Italian visit of 1913–14, and, say, *Landscape: Civray* (cat. 31), painted in the summer after *Still Life with Bottle of Marsala*, deep in the French countryside of Poitou. On the one hand, there is Severini responding to Futurist theory and practice, while attempting to write his own Futurist manifesto, Plastic Analogies in Dynamism, holed up on the Italian coast. On the other, there is Severini making his contribution to the Cubist war-time 'call-to-order', giving the fragmented idioms of Cubism a controlling grammar, and imposing it upon landscapes painted among close French friends in the calm of the French provinces.[8] And yet, Severini's Futurism was, in fact, as much embedded in a French context as it was part of an international campaign directed from Italy. Despite the irresistible Italian charisma of that term 'Futurismo', it would be easier to write an account of his 'Futurist' development without mentioning Italy than without mentioning France. His Futurism is often more closely attuned to what Guillaume Apollinaire called the 'Orphic Cubism' of Robert and Sonia Delaunay and Fernand Léger than it is to the Futurism of Boccioni and Giacomo Balla.

8. The term 'Call to order' (Rappel à l'ordre) was coined after the Armistice in 1918 by Jean Cocteau. It applied to a war-time shift towards structured composition in literature, music and the visual arts which was overtly related to a classical idea of the French tradition. This has been related to the accent on France as a 'Latin' nation, characterized by qualities of order and lucidity, in war-time cultural propaganda. Almost all the significant Paris-based Cubists, including Severini, became associated with Léonce Rosenberg's Galerie de l'Effort Moderne in the War, and that gallery took a leading role in the Cubist 'call-to-order' from 1916 into the 1920s. See Christopher Green, *Cubism and its Enemies, Modern Movements and Reaction in French Art, 1916–1928*, Yale University Press, New Haven and London, 1987; and Kenneth E. Silver, *Esprit de Corps: The Art of the Parisian Avant-Garde and the First World War, 1914–1925*, Princeton University Press, New Jersey, 1989.

Later, when he recalled his work of 1910–15, Severini himself liked to stress two French relationships: with the modern life Neo-Impressionism of Georges Seurat and with the modern life Cubism of Robert Delaunay and especially Léger. He was proud of his intimacy with Pablo Picasso and Georges Braque (the latter a Montmartre neighbour in the Impasse de Guelma in 1910–11), and did not conceal his alignment with them as portrait painter in 1912, but he saw himself as most importantly the discoverer, with Léger, of a modern sequel to Impressionism, where Picasso and Braque had reacted against it. Léger's 'ideas on dynamism and on complementary contrasts of line, form, and colour,'

9. *The Life of a Painter*, 1995, pp. 115–116.

Severini writes in his autobiography, 'always had many points in common with the ideas governing my early works in Paris, for we shared Seurat as our point of reference.'[9]

Léger was the French painter associated with the 1911–12 emergence of Cubism in the Salon des Indépendants and the Salon d'Automne, who responded most directly and positively to the Italian challenge. Indeed, he has rightly been accused of actually plagiarizing Boccioni's book *Dynamisme plastique et sculpture française* in the eulogies to modernity that filled his 1914 lecture, 'Contemporary Achievements in Painting', which was published influentially in Apollinaire's little magazine *Les Soirées de Paris*.[10] Léger was the most Futurist – most Italian – of the Montparnasse Cubists. It is, therefore, not surprising to find that his work provides as illuminating a context for Severini at his most Italian as that of Boccioni and Balla, even for the Severini of those thoroughly Futurist Anzio paintings dedicated to the themes of light-expansion and 'plastic analogy'. Such paintings as these had what it took to make as much of an impact on Cubists in Paris as on Futurists in Milan and Rome.

10. Léger's lecture was delivered at the Académie Wassilief (a free academy in Montparnasse). It was first published as 'Les réalisations picturales actuelles' in *Les Soirées de Paris*, no. 25, 15 June 1914. It is translated into English in Fernand Léger, *Functions of Painting*, edited and introduced by Edward F. Fry, Thames and Hudson, New York and London, 1973. Léger's debt to Boccioni's book, which appeared a couple of months earlier, is demonstrated by Giovanni Lista in *Fernand Léger*, 1990, exhibition catalogue (ed. Hélène Lassalle), Musée d'art moderne, Villeneuve d'Asq.

In 1913, Severini had met up again with his and Boccioni's teacher Balla in Rome. There can be no doubt that Balla's own experiments aimed at finding abstracted pictorial equivalents for the experience of speed and engine noise helped give Severini the confidence to arrive at the uncompromising abstraction of the light-expansion paintings. Yet their accompanying theory expressed in Severini's aborted manifesto, Plastic Analogies in Dynamism, with its recourse to the Neo-Impressionist colour theory of 'simultaneous contrasts', plainly echoes Robert Delaunay's 1913 adaptation of that theory (see fig. 1) and, above all, Léger's in his 1913 lecture 'The Origins of Painting and its Representational Value'.[11] At the same time, there can be no doubt that Marinetti's text of 1913 incorporating his Technical Manifesto of Literature, with its theory of analogy, was indeed the immediate stimulus behind Severini's plastic analogy paintings: Marinetti's plea was for 'an orchestral style', embracing 'the life of matter … by means of the most extensive analogies', which could bring together the most 'distant, seemingly diverse and hostile things'.[12] And yet, in the example of Léger's painting was a model of how the very process of abstraction could of itself lead to a new kind of analogy, revealed, not by words coming together to make metaphors – Marinetti's machine gun as *femme fatale* – but by pictorial line, form and colour reduced to elementary contrasts. Léger's series of *Contrastes de formes* of 1913 (see fig. 2) had emerged from a process of abstracting that allowed him to exchange freely the configurations with which he represented entirely different things: the rising curves of smoke became the curves of his *Nude Model in the Studio* at the Salon des

11. Severini's manifesto was aborted in the sense that it remained unpublished at the time. It has been published in English in Umbro Apollonio (ed.), *Futurist Manifestos*, Thames and Hudson, New York and London, 1973. Léger's lecture was delivered, like that of 1914, at the Académie Wassilief (see note 8). It was first published as 'Les Origines de la peinture et sa valeur représentative' in *Montjoie!*, 29 May and 14–29 June 1913, Paris. It is translated in Léger, 1973.

12. Marinetti's text first appeared dated 11 May 1913 in *Lacerba*, 15 June 1913, Florence. It has been published in English as 'Destruction of Syntax – Imagination without Strings – Words-in-Freedom' in Apollonio, 1973.

Indépendants of 1913 before they were further solidified to underpin the linear rhythms of the *Contrastes de formes*.[13] In Severini's Anzio pictures, the rhythms of *Expansion of Light (Centrifugal and Centripetal)*, 1913–14 (cat. 15), closely echo those of *Sea = Dancer*, 1914 (cat. 17), moving from the abstract to an open field of reference, where a single configuration can signify very different things: the movement of both the sea and a dancer – the view from an Italian shore and memories of Parisian cabarets. Severini operates here as a painter experienced in the workings of French modernism, however responsive he is to Balla's new enthusiasms and the insistent demands of Marinetti's manifestos.

Severini published the first volume of his autobiography, *The Life of a Painter*, in 1946, just a couple of years after the defeat of Fascist Italy. Given the Futurists' clumsy and often unreciprocated support for the hyper-active authoritarianism of Mussolini's regime, there was clearly good reason to distance himself from Marinetti's movement, with its disciplined group policies and its intolerance of any opposition. And yet, Severini identified something at the core of his own relationship with Futurism when he set up the movement as an Italian alternative – the model of the modern movement at its most collective – to the plural, anarchic realities of Montmartre and Montparnasse as he experienced them. Severini sums up the situation in *The Life of a Painter*: 'The root of the problem was this: while Boccioni was strolling from one European capital to another, a

13. I have analysed this in detail in Christopher Green, *Léger and the Avant-Garde*, Yale University Press, New Haven and London, 1976, chapter 3.

fig. 1
Robert Delaunay
Windows open Simultaneously, first part, third motif, 1912
oil on canvas, 45.7 x 37.5 cm
Tate Gallery, London

fig.2
Fernand Léger
Contrasting Forms, 1913
gouache, 44.7 x 54 cm
A. Rosengart Collection

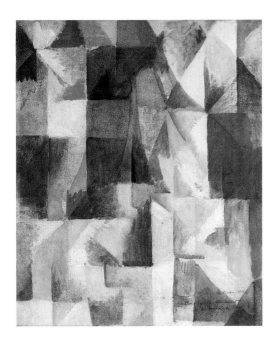

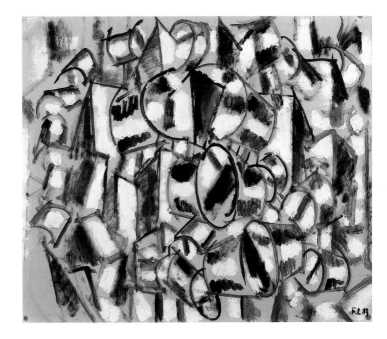

14. *The Life of a Painter*, 1995, pp. 123–124.

travelling salesman for Futurism … , and while in Milan they were exceedingly busy producing manifestos … , in Paris each artist was working and progressing according to his own personal conclusions.'[14]

Certainly between the 1880s and 1914, liberal democratic France was characterized by the proliferation of small groups, both in politics and culture (its first properly constituted political party, the Parti Radical, was a loose alliance of local groups). Certainly Cubism, even the more disciplined 'call-to-order' version to which Severini attached himself in 1916–17, was never a movement in the same sense as Futurism. Cubism's most widely accepted leader, Picasso, impatiently refused the role, and from the outset it was represented by competing theories as well as practices, sometimes (as in the case of Apollinaire's short anthology *Les Peintres cubistes* of 1913) in a single text. When Boccioni wrote to Severini in 1910 asking him for his adhesion to Futurism and to recruit other artists in Paris, Modigliani declined the invitation to be involved and also advised Severini against it.[15] From that moment, Severini would be pulled between what might be called the Modigliani and the Marinetti principles: between individualist pluralism and collective solidarity. To begin with Paris and Milan stood unambiguously for those opposing principles.

15. Ibid, p. 80.

The 'call-to-order' Cubism, which gained such cohesion around the dealer Léonce Rosenberg's Galerie de l'Effort Moderne between 1916 and the early 1920s, might never have given Cubism a real collective presence comparable with Marinetti's movement, but, in his autobiography Severini treats it as a comparable threat to his independence. 'I never belonged to "the disciplined troop",' he writes, alluding to André Salmon's contemptuous rejection of L'Effort Moderne Cubism in those terms in 1918.[16] If, however, he stressed in retrospect the degree to which he was repulsed by the cohesive demands of 'call-to-order' Cubism, he was also indisputably attracted to it at the time. Indeed, his relationship with both Italian Futurism and French Cubism can be explored in terms of the shifts in his own position as an artist between the model of an engaged, collectivist modernism driven by theory, and that of an independent, individualist modernism driven by an intuitive artistic practice. There were moments when the rallying cries of movements, their slogans and their totalizing theories, did not repulse him at all, but drew him to them, attracting his commitment to the point of obsession. Alongside the risk-taking daring that went with the uprootedness of an immigrant, there went, predictably enough, a real need for the security of group membership and of certainty. His painting between 1910 and 1920 was always experimental, sometimes assertively individual, even when it was

16. Ibid, p. 61. André Salmon's dismissal of the Cubist 'school' associated with Léonce Rosenberg's Galerie de l'Effort Moderne is expressed with force in his article 'Cubisme et camouflage' in *L'Europe Nouvelle*, no. 39, 5 October 1918, p. 1876.

calmed by the stabilizing devices of 'call-to-order' Cubism. Its context often consisted of groups dedicated to theory as a mode of control.

In 1921, the poet-critic Pierre Reverdy, an old Montmartre friend of Severini and by that date a leading theorist of Cubism, summed up the condition of the Paris vanguard as follows: 'All the young elements are tossed back and forth between two contrary sentiments: first, an unconscious even imperious need for a common direction, a single way, a grouping, even a generalization of the most personal discoveries; then, an extreme pride of authorship, an absolute individualism, a thirst for excessive originality which one finds to the same degree among the most banal, the most commonplace, the most anonymous, one might say altogether the flattest imitators.'[17] His diagnosis of a Paris-wide condition in the early 1920s fits exactly the individual case of Gino Severini between his adhesion to Futurism in 1910–11, and his publication in 1921 of *Du cubisme au classicisme*. This text, which appeared in the same year as Reverdy's remarks, was Severini's most compulsively controlling statement as a theoretician, but it represents just one swing of a pendulum. Indeed, in its Parisian context it appeared so much a swing too far that, paradoxically, it identified Severini as an exception, distinct and individual in the very rigour of his pursuit of a collective 'classical' theory. Maurice Raynal, another old Montmartre friend, was, of all the critics sympathetic to Cubism, the most attracted to controlling theories; but even he dismissed Severini's book as aberrant.[18]

Severini aligned himself with the Futurists from a position of confident strength as a painter. 1910–11 was the period when he established himself not only as a corresponding and visiting member of Marinetti's movement, but in the Parisian milieux of Picasso, Braque, Apollinaire and Max Jacob as well as Paul Fort and the Salon Cubists who frequented the Closerie des Lilas, including Léger and the Delaunays. It was Severini who introduced Boccioni, Carrà and Russolo to Cubist painting in 1911; his visit to them in Milan that summer had convinced him of the need to give them an immersion course in Parisian painting in order to save them from what seemed to him their provincial ways as artists. He had been confident enough to show Picasso his *Boulevard* (cat. 2) when they met through Apollinaire, and indeed that work's flat, angular division of the picture plane gave pictorial immediacy to its urban subject in a way clearly distinct from Picasso's own, more studio centred experiments. Yet, even in that painting one can read the signs of a drive towards a kind of certainty that never attracted either Picasso or Braque. Already Severini works with studies towards a crisply laid out definitive image – as he consistently would throughout this period – whereas Picasso and Braque worked directly on the

17. Pierre Reverdy, 'L'esthétique et l'esprit' in *L'Esprit Nouveau*, no. 6, March 1921, Paris.

18. Maurice Raynal, 'Les arts' in *L'Intransigeant*, Monday, 7 August 1922. I discuss Raynal's attack on Severini's *Du cubisme au classicisme* in Green, 1987, pp. 155–156.

canvas, exploring as they painted, combining the open-ended character of drawing with that of the oil sketch. Severini might have brought an assertive French *savoir-faire* to the ambitious Italians, but he was ready for the lesson they immediately taught him: that the need for certainty was most effectively satisfied by the development of controlling theories.

19. The fullest discussion of Bergson and the Parisian avant-garde is Mark Antliff, *Inventing Bergson. Cultural Politics and the Parisian Avant-garde*, Princeton University Press, New Jersey, 1993. Also see Brian Petrie, 'Boccioni and Bergson' in *The Burlington Magazine*, vol. 116, March 1974.

Boccioni reciprocated Severini's introductory course on Parisian avant-garde art by involving him at close quarters with the dynamics of Henri Bergson's anti-positivist philosophy which was, in fact, already influential in Salon Cubist circles.[19] Bergsonian notions of flux immediately re-directed Severini's painting, the dynamism of experience becoming its central theme not only in visual but also in psychological terms, so that the mobility of memory in experience could provide the subject-matter of a picture like *Memories of a Journey* (cat. 1). Painted in 1911, either immediately before or immediately after *The Boulevard*, this was a picture that fitted into the Bernheim-Jeune exhibition so well, because it was clearly theory-driven in a way entirely at one with most of the other Futurist work there. Severini claimed in his autobiography to be a reluctant manifesto-writer when he answered Marinetti's request for a manifesto with Plastic Analogies in Dynamism, and *Lacerba* (the Futurist periodical) never published it. But, as Anne Coffin Hanson points out, Severini's correspondence with Marinetti demonstrates a dogged commitment to its composition.[20] Moreover, not only is the fit between the Anzio pictures and the theory expounded there very snug indeed, but also the text's rhetorical language is as comprehensive, as all-controlling and, indeed, as totalizing in the grandest universal sense as in any text that Severini would produce, including *Du cubisme au classicisme*. This is the writing of a painter who has bought the Futurist theory package with unconfined enthusiasm. It is hardly surprising, given Severini's own need to belong, together with the fact that several leading lights of Salon Cubism had begun to publish theory too: Gleizes and Metzinger as well as Apollinaire, Robert Delaunay and Léger.

20. Anne Coffin Hanson, Introduction to *The Life of a Painter*, 1995, pp. xi–xii.

The Bergsonian belief that the movement of past into present and future – something that could only be grasped intuitively in the immediacy of experience – was the sole universal truth open to the individual, underpinned a broad tendency to tie art to 'the universal' in French as well as Futurist theories. However, whereas French statements were fragmentary and uncoordinated, Severini's manifesto was one statement among many in a centrally directed campaign, whose breathtaking claims to direct every aspect of a possible modern art were made in absolute earnest. The theory behind the light-expansion paintings demanded the use of '*all the colours in the prism*'. They were conceived as 'the

coloured expression of the sensation of *light*': all light, therefore all visual experience. The theory behind the plastic analogy paintings claimed to expose the connecting principle common to all mental experience. The 'UNIQUE FORM, CREATED BY MY SENSIBILITY' – on the level both of sensation and of thought – 'is,' Severini claimed, no less than 'the expression of the absolute vitality of matter or universal dynamism.'[21] Fernand Léger might have borrowed a little of the Futurists' modernizing rhetorical energy, but such sublimely confident claims of access to transcendent truth remained out of his reach.

21. Severini (1913) in Apollonio, 1973, pp. 120–125.

When Severini showed his home-front war pictures at the Galerie Boutet de Monvel in January 1916, they were accompanied by a theoretical statement, and when, later that year, he sent a selection of them with some of his first Cubist still lifes to be shown at the 291 Gallery in New York, another followed. In 1917, his definitive move into Cubist idioms was accompanied by a further three such statements. When he exhibited, he now liked to lecture as well. Through 1916 and 1917 he became one of the most publicly articulate of the Parisian modernists who were not at the Front, publishing regularly in *Mercure de France* and the new magazine *S.I.C. (*Sons. Idées. Couleurs.) edited by a Montparnasse neighbour, Pierre Albert-Birot. He painted and exhibited, and he talked too: with Matisse in his home at Clamart, with the emergent painter-theorist Amédée Ozenfant, with his new dealer Léonce Rosenberg and the other artists who signed contracts with him – Juan Gris, Diego Rivera, Jacques Lipchitz and Maria Blanchard, among others.

His need for the support of theory did not mean that he became any less experimental in his painting. When he turned to Cubist idioms, he took on board the open-ended, exploratory nature of Cubist practice, even if he continued to work with studies towards definitive compositions. A close look at 1917 pictures such as *Still Life with Bottle of Marsala* (cat. 32) alongside, for instance, the 1916 *Still Life with White Grapes* (cat. 29) or the 1919 *Still Life: Music* (cat. 37) reveals how open to change Severini's Cubism was. Just as he had pursued different lines in his Futurism (the light-expansion paintings alongside the plastic analogies, for instance), he was plural in his openness, exhibiting Neo-Classical portraits of Jeanne in 1916 and 1917 (see p. 15), even as he developed his Cubist practice. However, his rhetoric as a theoretician attached to 'call-to-order' Cubism retained the accent on control and on all-inclusiveness so characteristic of his Futurist theory.

There is not the space here to elucidate the Mallarméan poetics that gave theoretical support to Severini's war-paintings, or his elaborate appropriation of currently fashionable notions of physics and n-dimensional geometry for application to Cubist modes of

representation, but the rhetoric of control is present everywhere. He subtitled his 1917 text *La peinture d'avant-garde*, 'Machinism and Art – the Reconstruction of the Universe'. Theory allowed him to believe that every machine was a 'reconstruction of the Universe' in its entirety, and that his paintings could be too. His rationale for his move into Cubism is that by making this move he can achieve a more total art in these transcendent terms, one that combines the weightless immediacy of colour with the gravitational solidity of form, the 'dynamism' of sensibility with the order of 'intelligence', the subjective with the objective. He ends that text by hoping for a final reconciliation of opposites: the individual with the collective. But his ultimate goal is unequivocal: a 'collective aesthetic', preparing the way to 'universality and style'.[22] Throughout these texts, theory, whether poetic, quasi-scientific or quasi-mathematical, functions as a guarantor of authority. Severini – an autodidact who was expelled from the Italian school system at the age of fifteen – sets himself up as intellectual leader aspiring to total control on the same elevated plane as the Marinetti whose loud-speaker leadership had so attracted and repulsed Severini before the War.

The 'call-to-order' in French modernism between 1916 and the early 1920s is sometimes presented as if it had real coherence and effective leaders, as if figures like Reverdy and Rosenberg (not so obviously Severini) briefly enjoyed real control. They never, however, controlled more than tiny groupings of supporters, and then always tenuously, in a free market situation that remained highly individualistic. Severini's plea for a 'collective aesthetic' was made against what he called the 'ultra-individualism' that still, he confessed candidly, was all around him. His problem as aspirant intellectual dictator was that France – the one European country where, from around 1900, intellectuals could be treated as a social class – provided a cultural environment where plurality continued the rule, where, especially within its cultural avant-gardes, borders were to be crossed, whoever claimed to control them.

22. Gino Severini, 'La peinture d'avant-garde' in *Mercure de France*, June 1917, Paris; in Serge Fauchereau (ed.), *Severini: Ecrits sur l'art*, Diagonales, Editions Cercle d'Art, Paris, 1987, pp. 79–95. This piece was delivered as a lecture at the opening of a mixed exhibition, including Severini, put on by the loosely organized association 'Lyre et Palette' at 6 rue Huyghens, 28 January 1917.

Plates

The plate numbers correspond
with the catalogue numbers in the List of Works

1

Memories of a Journey

1910–11

2
The Boulevard
1910–11

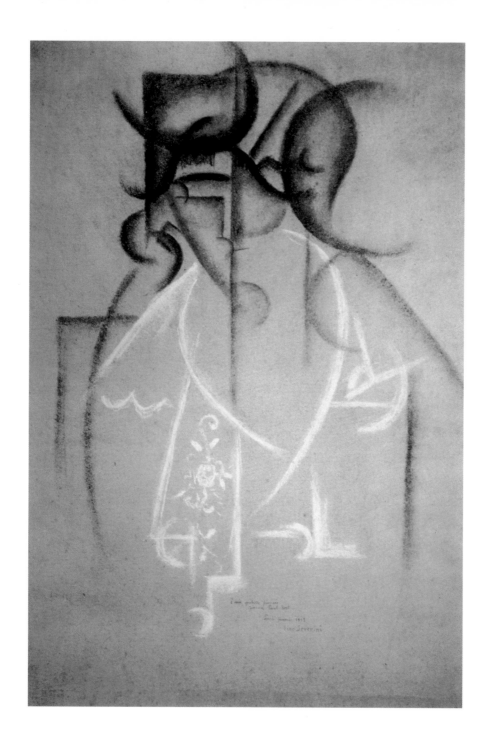

10
Portrait of Mlle Jeanne Paul Fort
1912–13

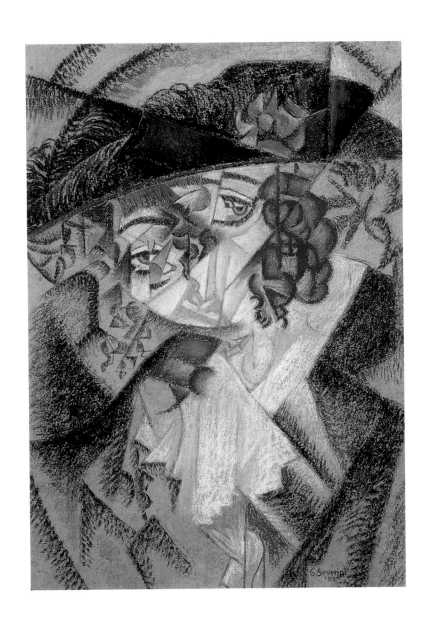

3
Portrait of Madame MS
1912

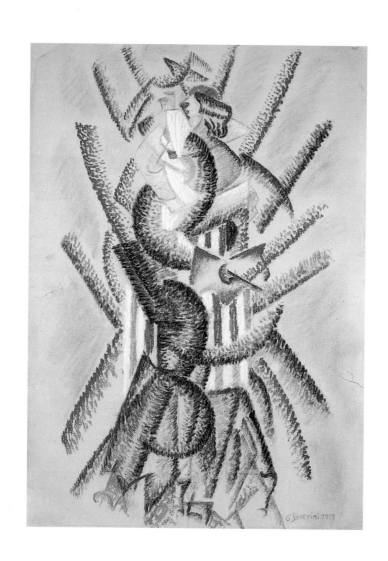

4
The Bear Dance
1912

5
The Bear Dance
1913

6
Spanish Dancer at the Tabarin
1912–13

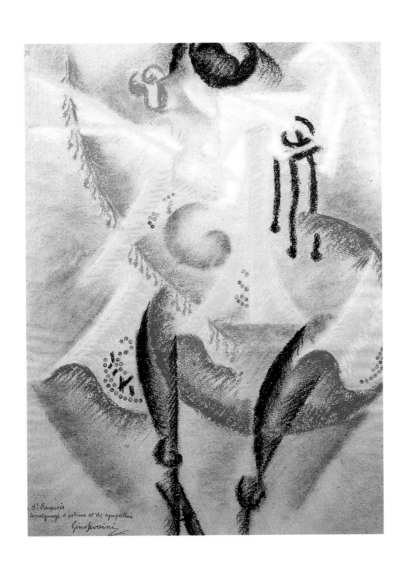

7
Dancer
1913

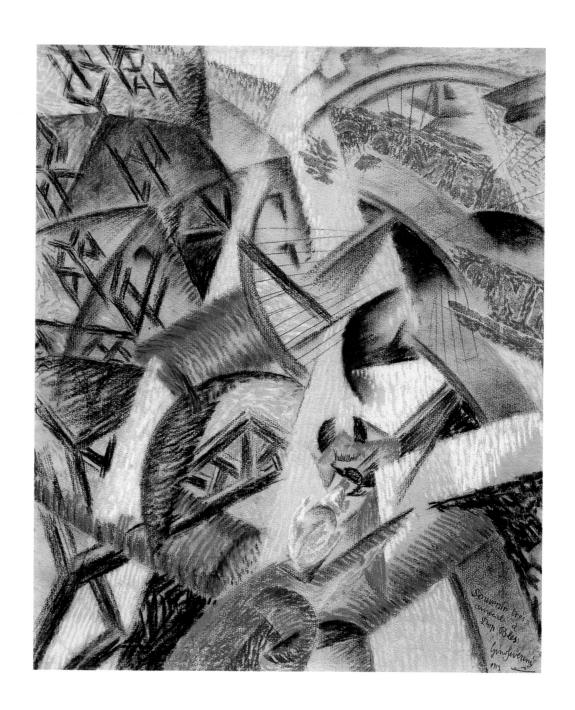

8
The Eiffel Tower
1913

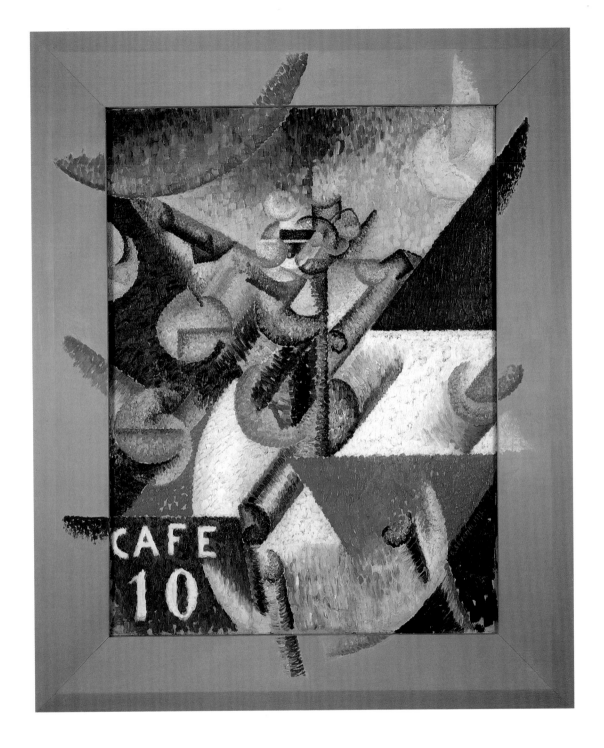

9
Plastic Rhythm of 14 July
1913

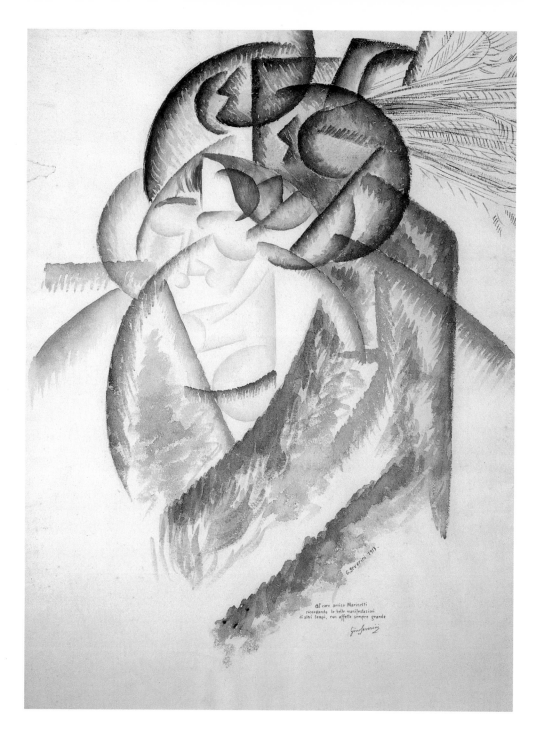

12

Portrait of Mlle Suzanne Meryon of the Variété

1913

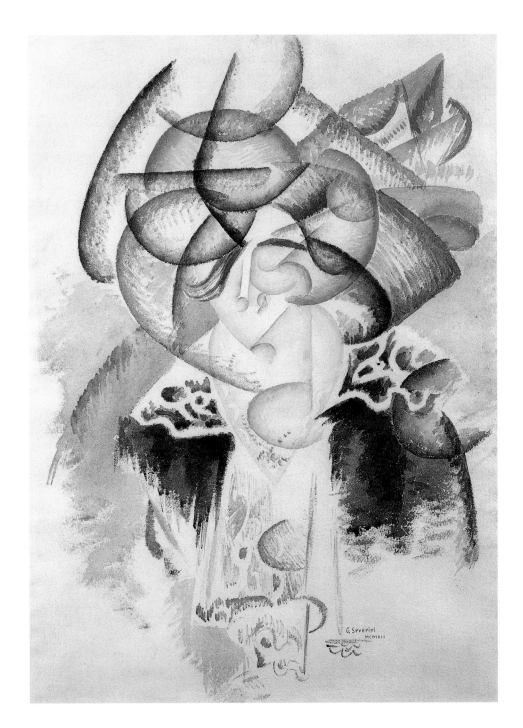

11

Portrait of Mlle Jeanne Paul Fort

1913

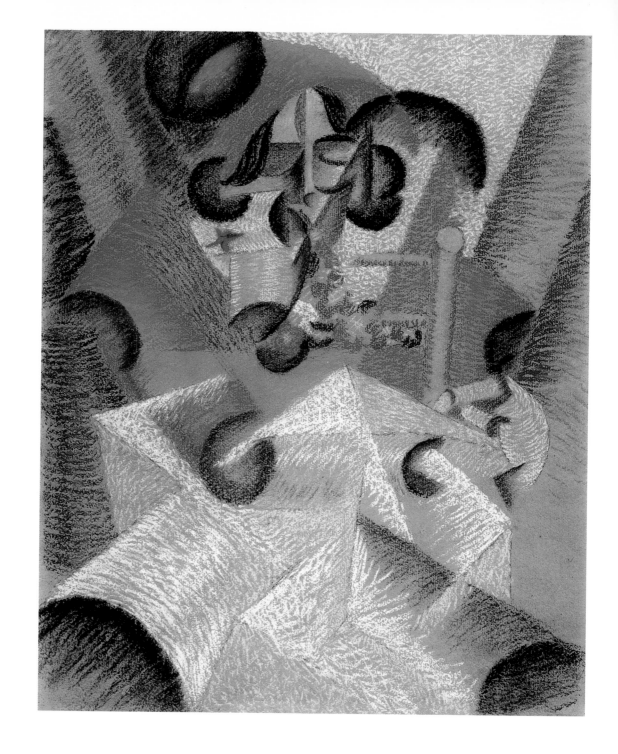

13
Portrait of a Woman
1913

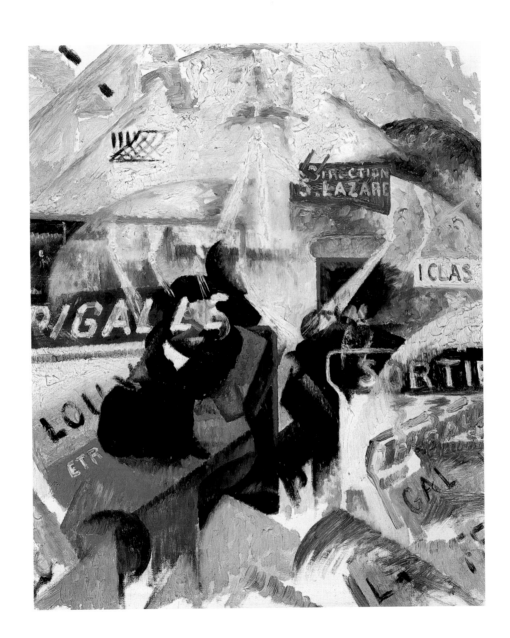

14
Study for 'Nord-Sud'
1913

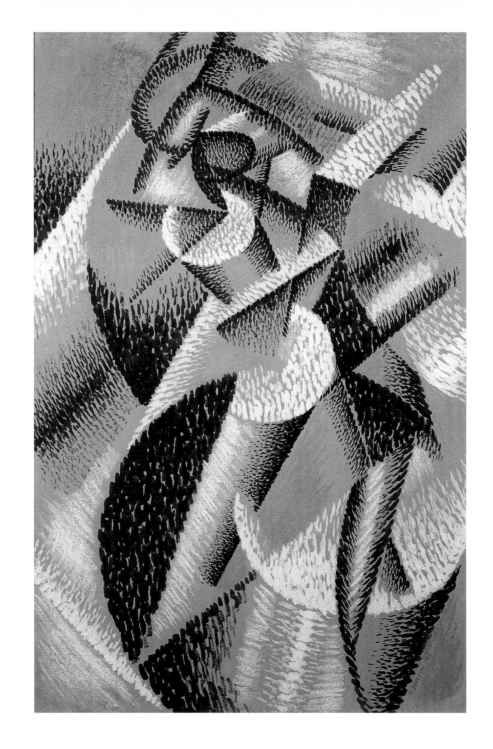

16
Dancer + Sea
1913

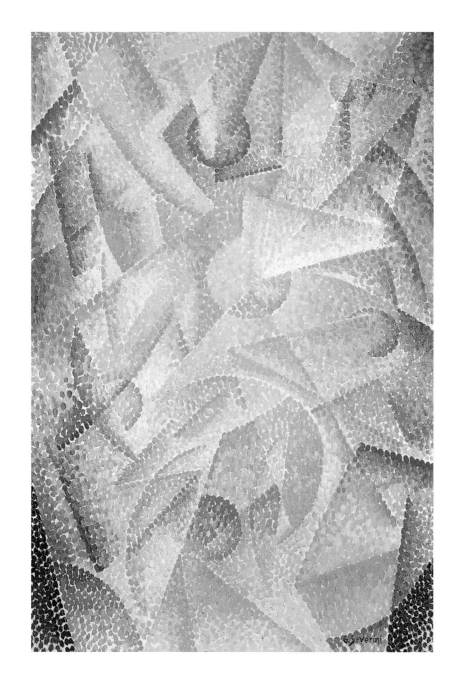

15
Expansion of Light (Centrifugal and Centripetal)
1913–14

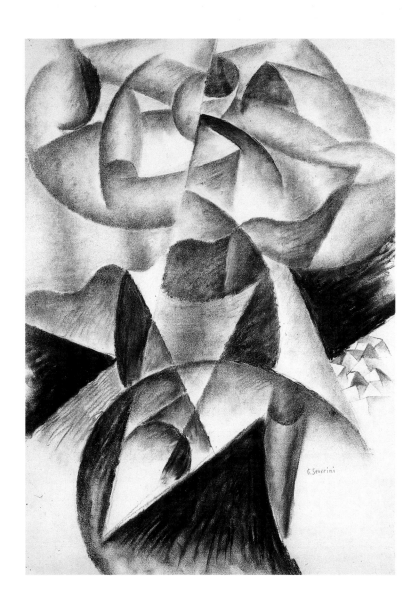

18
Study for 'Sea = Dancer'
1914

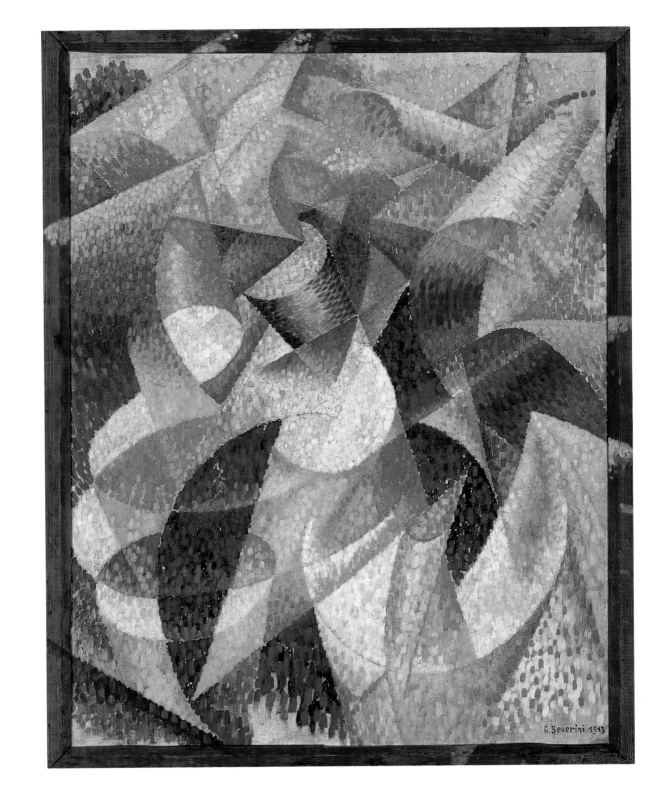

17
Sea = Dancer
1914

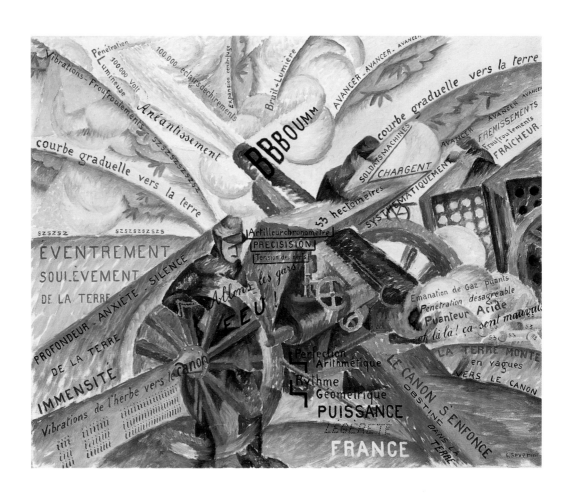

19
Cannon in Action
1914–15

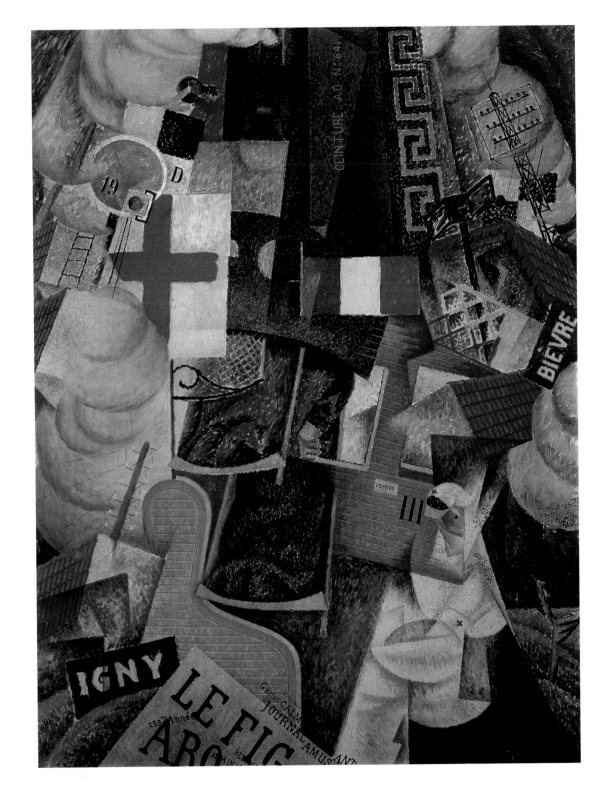

20
The Hospital Train
1915

22
Train Arriving in Paris
1915

21
Surburban Train Arriving in Paris
1915

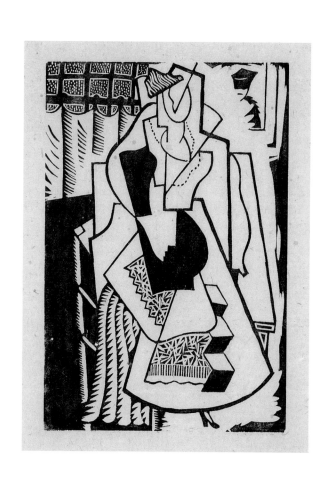

24
The Dressmaker
1916

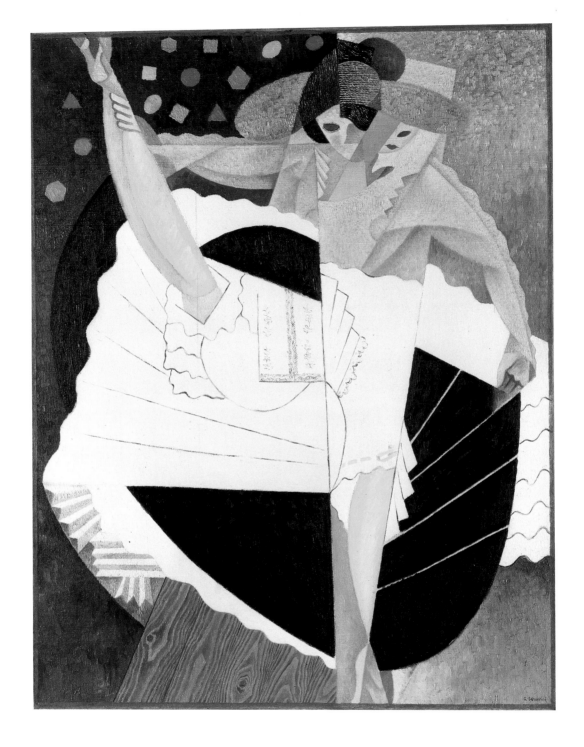

23
Dancer
1915–16

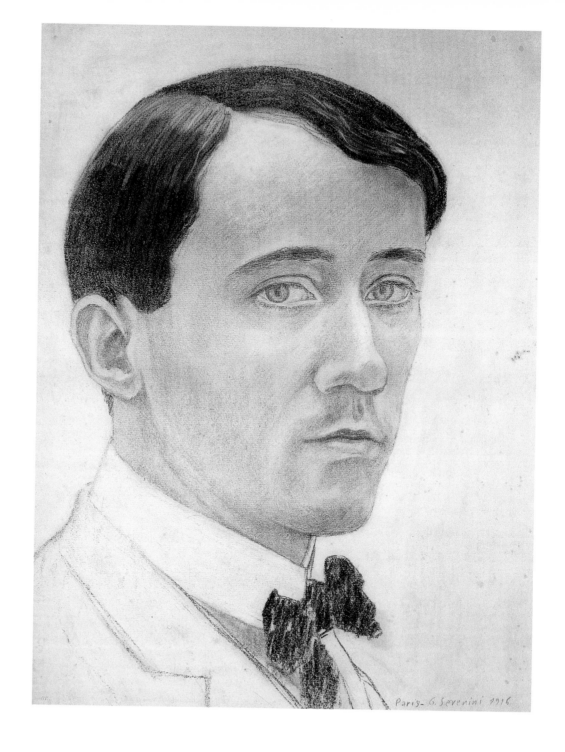

26
Self-Portrait
1916

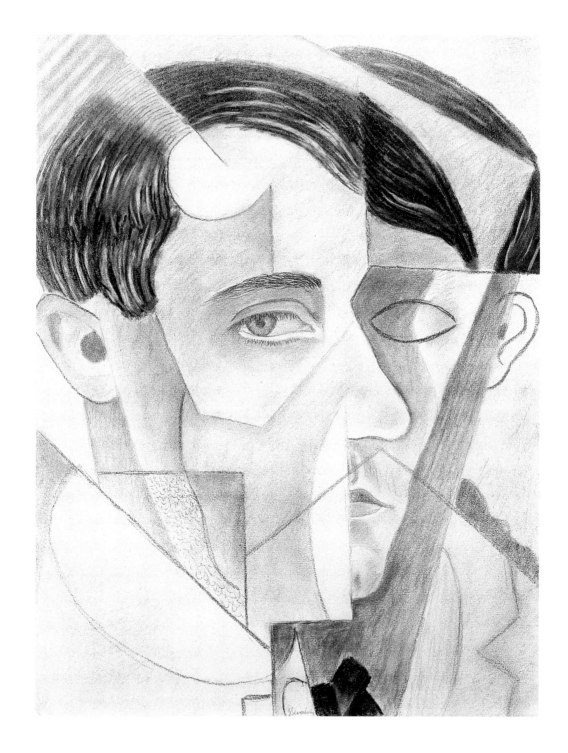

25
Self-Portrait
1916

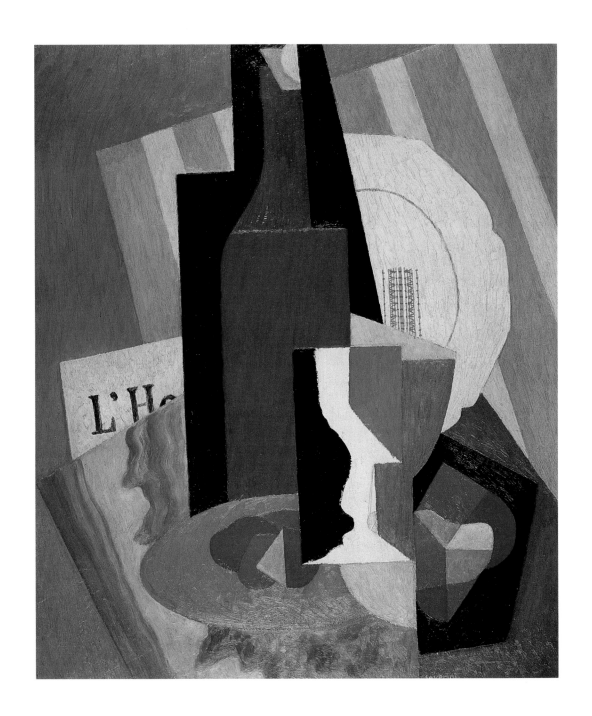

27
Still Life
1916

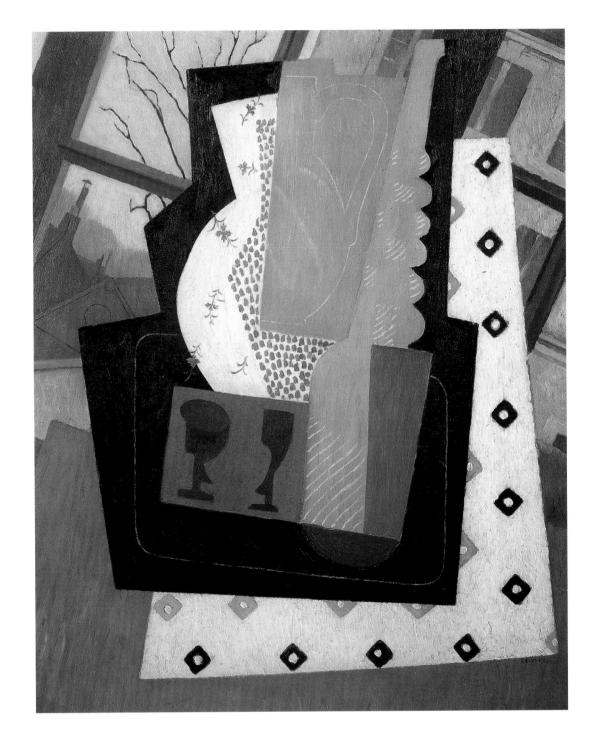

28
Still Life in Front of the Window
1916

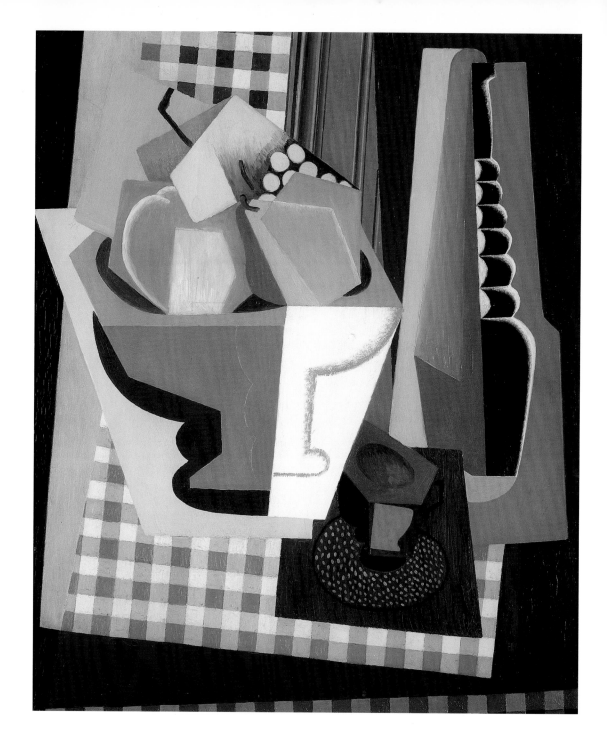

29
Still Life with White Grapes
*c.*1916

30
Cubist Still Life: Quaker Oats
1917

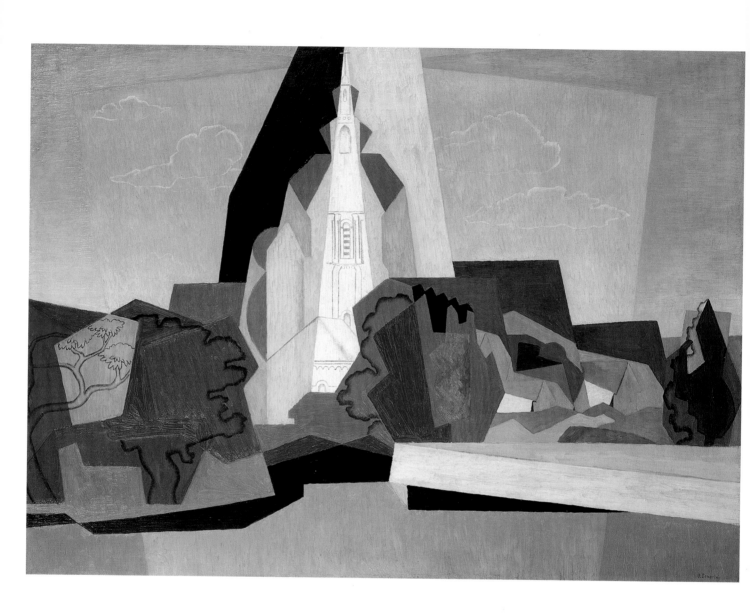

31
Landscape: Civray
1917

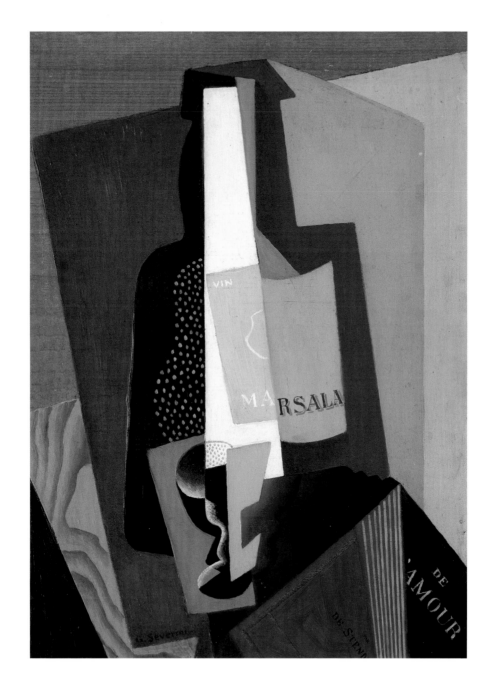

32
Still Life with Bottle of Marsala
1917

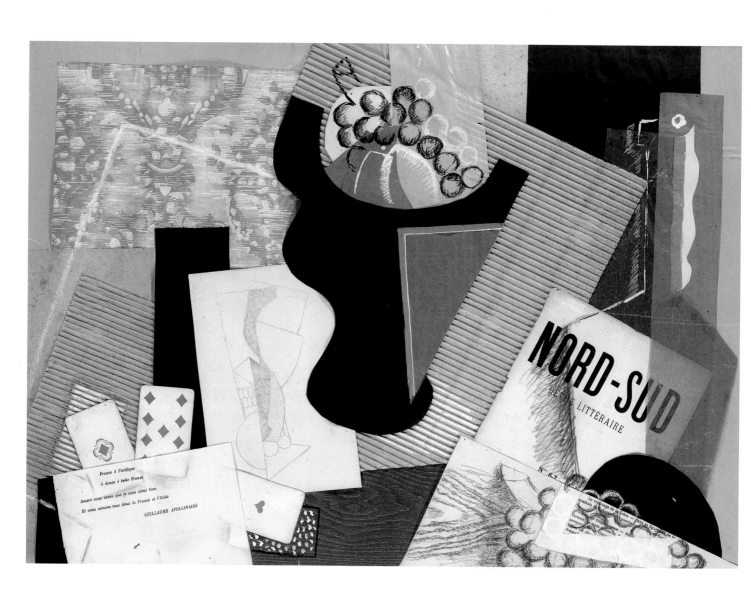

33
Still Life with Literary Review 'Nord-Sud'
(Homage to Reverdy)
*c.*1917

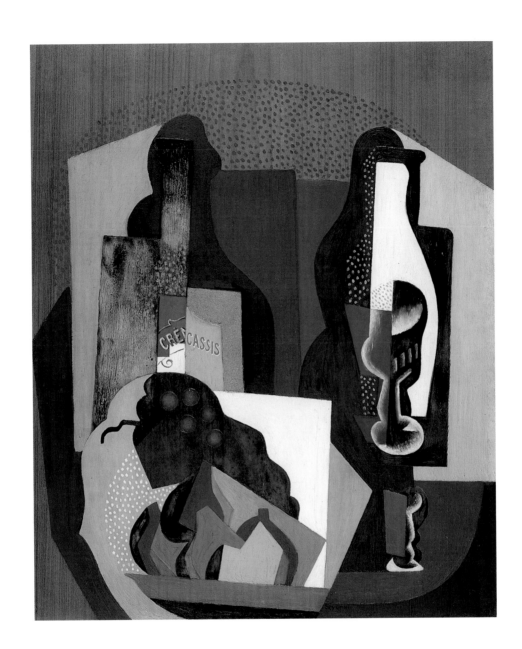

34
Still Life
1918

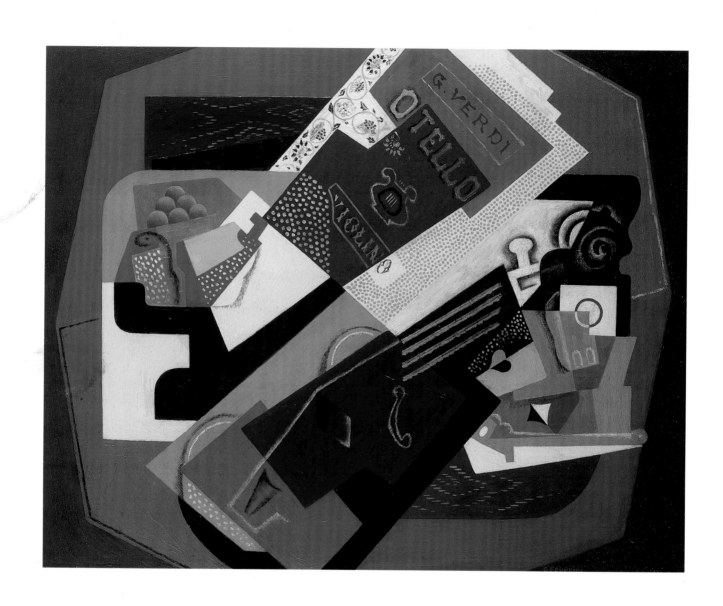

37
Still Life: Music
1919

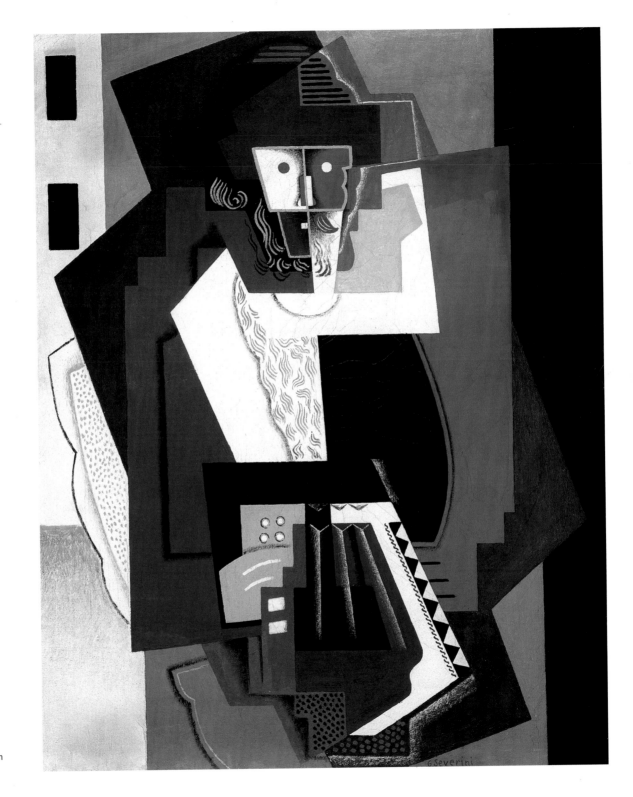

35
Gypsy Playing the Accordion
1919

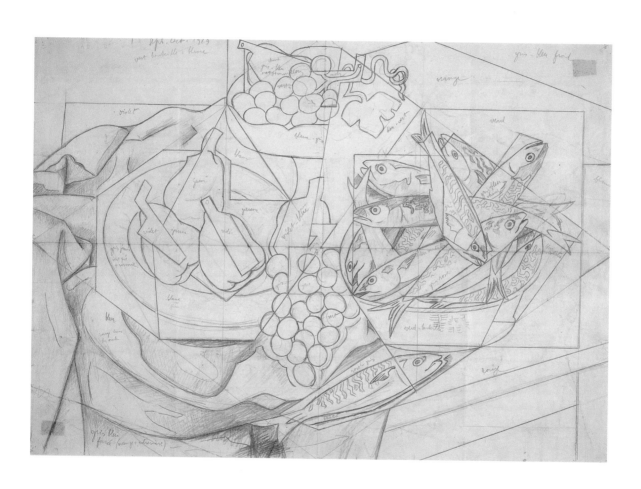

38
Study for 'Still Life with Fish'
1919

List of Works and Select Bibliography

List of Works

All measurements are given as
height x width.
All numbers preceded by F refer to
Daniela Fonti, *Gino Severini: Catalogo
ragionato*, Arnoldo Mondadori,
Milan, 1988

1
Memories of a Journey, 1910–11
*Souvenirs de Voyage (Ricordi di
viaggio)*
oil on canvas
81.2 x 99.8 cm
Private collection (courtesy Galleria
dello Scudo, Verona)
F 90

2
The Boulevard, 1910–11
Le Boulevard
oil on canvas
63.5 x 91.5 cm
Estorick Foundation, London
F 92

3
Portrait of Madame MS, 1912
Ritratto di Madame MS
pastel on paper
48 x 37 cm
Private collection
F 104a
(Not included in the exhibition)

4
The Bear Dance, 1912
La Danse de l'Ours
pastel on paper
53 x 38 cm
Private collection
F 124

5
The Bear Dance, 1913
La Danse de l'Ours
watercolour on paper
76.5 x 55 cm
Private collection
F 125

6
Spanish Dancer at the Tabarin, 1912–13
Ballerina Spagnola al Tabarin
charcoal on paper
54 x 44 cm
Private collection
F 114

7
Dancer, 1913
Danseuse
pastel, charcoal, chalk and
sequins on paper
40 x 29.9 cm
Private collection, Lugano

8
The Eiffel Tower, 1913
La Tour Eiffel
pastel on paper
55.5 x 47 cm
Private collection
F 151

9
Plastic Rhythm of 14 July, 1913
Ritmo Plastico del 14 Luglio
oil on canvas
60 x 50 cm
Severini Franchina Collection
F 158

10
Portrait of Mlle Jeanne Paul Fort,
1912–13
Ritratto di Mlle Jeanne Paul Fort
charcoal and tempera on yellow paper
64 x 47 cm
Romana Severini Collection
F 118

11
Portrait of Mlle Jeanne Paul Fort, 1913
Ritratto di Mlle Jeanne Paul Fort
watercolour on paper
76.2 x 54.5 cm
Private collection
F 156

12
**Portrait of Mlle Suzanne Meryon of the
Variété,** 1913
*Ritratto di Mlle Suzanne Meryon del
Variété (Danzatrice II)*
watercolour on paper
76 x 56 cm
Estorick Foundation, London
F 155

13
Portrait of a Woman, 1913
Ritratto Femminile
pastel on thin cardboard
66 x 56 cm
Private collection
F 153

14
Study for 'Nord-Sud', 1913
Studio per 'Nord-Sud'
oil on canvas
55 x 46 cm
Private collection
F 132

15
**Expansion of Light (Centrifugal
and Centripetal),** 1913–14
Expansion de la Lumière (Centrifuge)
oil on canvas
68.5 x 43.2 cm
Museo Thyssen-Bornemisza, Madrid
F 201

16
Dancer + Sea, 1913
Danseuse (Ballerina + Mare)
oil and pastel on paper
76 x 51.5 cm
Estorick Foundation, London
F 186

17
Sea = Dancer, 1914
Mer = Danseuse (Mare = Ballerina)
oil on canvas
105.4 x 85.9 cm (framed)
Peggy Guggenheim Collection, Venice
(Solomon Guggenheim Foundation)
F 185

18
Study for 'Sea = Dancer', 1914
Studio per 'Mare = Ballerina'
charcoal on paper
70 x 50 cm
Private collection
F 188a

19
Cannon in Action, 1914–15
*Canon en Action (Mots en liberté
et formes)*
oil on canvas
50 x 60 cm
Museum Ludwig Köln (Foundation VAF)
F 217

20
The Hospital Train, 1915
Train de Blessés
oil on canvas
118 x 90.5 cm
Stedelijk Museum, Amsterdam
F 231

21
Suburban Train Arriving in Paris, 1915
Train de Banlieu Arrivant à Paris
oil on canvas
89 x 116 cm
Tate Gallery, London
Purchased with assistance from a
member of the National Art Collections
Fund 1968.
F 235

22
Train Arriving in Paris, 1915
Train Arrivant à Paris
charcoal and chalk on paper
47 x 55.5 cm
Private collection
F 235a

23
Dancer, 1915–16
Danseuse
oil on canvas
93 x 73 cm
Pallant House Gallery, Chichester
Kearley Bequest (through NACF) 1989
F 254

24
The Dressmaker, 1916
La Modiste
linocut
18.9 x 12.8 cm
The Gecht Family Collection, Chicago

25
Self-Portrait, 1916
Autoritratto
charcoal and pencil on paper
53.3 x 40 cm
The Gecht Family Collection, Chicago
F 259

26
Self-Portrait, 1916
Autoritratto
charcoal on paper
52 x 39 cm
Romana Severini Collection
F 259a

27
Still Life, 1916
Nature Morte
oil on canvas
54.5 x 45.5 cm
Assitalia Collection – INA Group
F 262

28
Still Life in Front of the Window, 1916
Nature Morte Devant la Fenêtre
oil on canvas
61 x 50 cm
The Gemeentemuseum Den Haag,
The Hague, The Netherlands
F 270

29
Still Life with White Grapes, *c.*1916
*Nature Morte aux Raisins Blancs
(Bocal de fruits; Compotier sur nappe
à carreaux I)*
oil on canvas
61 x 50 cm
The Gemeentemuseum Den Haag,
The Hague, The Netherlands
F 280

30
Cubist Still Life: Quaker Oats, 1917
Nature Morte: Quaker Oats
oil on canvas
60 x 51 cm
Estorick Foundation, London
F 283

31
Landscape: Civray, 1917
Paysage: Civray
oil on canvas
72.5 x 100 cm
Civico Museo d'Arte Contemporanea –
Boschi Collection
F 295

32
Still Life with Bottle of Marsala, 1917
Natura Morta con Bottiglia di Marsala
oil on board
42 x 32.5 cm
Thyssen-Bornemisza Collection,
Switzerland
F 287

33
Still Life with Literary Review 'Nord-Sud' (Homage to Reverdy), *c.*1917
*Nature Morte à la Revue Littéraire
'Nord-Sud' (Hommage à Reverdy)*
collage, gouache, charcoal and pencil
on board
55 x 77 cm
Private collection, Switzerland
(courtesy Julian Barran Ltd)
F 353

34
Still Life, 1918
Natura Morta
oil on board
60 x 51 cm
Private Collection
F 306

35
Gypsy Playing the Accordion, 1919
Bohémien Jouant de l'Accordéon
oil on canvas
92 x 72.5 cm
Civico Museo d'Arte Contemporanea –
Boschi Collection
F 366

36
**Study for 'Gypsy Playing the
Accordion',** 1919
*Tracciato per 'Bohémien Jouant de
l'Accordéon'*
pencil, charcoal and tempera on paper
120 x 80 cm
Franchina Collection
F 366a

37
Still Life: Music, 1919
*Natura Morta con Violino e Spartito
(Nature Morte: Musique)*
oil on canvas
65 x 81 cm
The Gemeentemuseum Den Haag,
The Hague, The Netherlands
F 357

38
Study for 'Still Life with Fish', 1919
Tracciato per 'Natura Morta con Pesci'
pencil on paper
45.5 x 64.5 cm
Romana Severini Collection
F 372

39
**Still Life with Pear and Playing
Cards,** 1919
Natura Morta con Pera e Carte da Gioco
Tempera and oil on board
33.7 x 23.5 cm
Private collection
F 362
(Not illustrated)

Select Bibliography

Apollonio, Umbro (ed.), *Futurist Manifestos*, Thames and Hudson, London, 1973

Bozzolla, Angelo and Tisdall, Caroline, *Futurism*, Thames and Hudson, London, 1977

Coffin Hanson, Anne, *Severini Futurista 1912–1917*, exhibition catalogue, Yale University Art Gallery, New Haven, 1995

Fonti, Daniela, *Gino Severini: Catalogo ragionato*, Arnoldo Mondadori, Milan, 1988 (contains a complete bibliography up to 1988)

Fonti, Daniela, *Gino Severini: Opere inedite e capolavori ritrovati*, Skira, Milan, 1999 (includes English translation)

Futurismo 1909–1919: Exhibition of Italian Futurism, exhibition catalogue, Northern Arts and the Scottish Arts Council, 1972

Green, Christopher, *Cubism and its Enemies: Modern Movements and Reactions in French Art*, 1916–1928, Yale University Press, New Haven and London, 1987

Hulten, Professor Pontus, *Futurism & Futurisms*, Thames and Hudson, London, 1992

Lukach, Joan, 'Severini's 1917 Exhibition at Steiglitz's "291" ' in *The Burlington Magazine*, vol. CXIII, no. 817, April 1971, pp. 196–206

Lukach, Joan, 'Severini's Writings and Paintings, 1916–1917, and His Exhibition in New York City' in *Critica d'Arte*, 138, November–December 1974, pp. 59–80

Martin, Marianne W., *Futurist Art and Theory*, 1909–1915, Clarendon Press, Oxford, 1968

Quinsac, Annie-Paule, *La Peinture divisionniste italienne: Origines et premiers développements* 1880–1895, Editions Klincksieck, Paris, 1972

Pacini, Piero, 'Gino Severini: L'Unanimismo di Jules Romains e le danze cromatiche di Loic Fuller I' in *Antichità Viva*, 29, no. 6, 1990, pp. 44–53

Pacini, Piero, 'Gino Severini: L'Unanimismo di Jules Romains e le danze cromatiche di Loic Fuller II' in *Antichità Viva*, 30, nos. 4–5, 1991, pp. 57–64

Severini, Gino, *Du cubisme au classicisme (Esthetique du Compas et du Numbre)*, Povolozky, Paris, 1921; reprinted in Pacini, Piero (ed.), *Dal cubismo al classicismo e altri saggi sulla divina proporzione e sul numero d'oro*, Florence, 1971

Severini, Gino, *Ecrits sur l'art*, edited by Serge Fauchereau, Diagonales, Editions Cercle d'Art, Paris, 1987

Severini, Gino, *The Life of a Painter: The Autobiography of Gino Severini*, translated by Jennifer Franchina, introduction by Anne Coffin Hanson, Princeton University Press, New Jersey, 1995

Silver, Kenneth, *Esprit de Corps, The Art of the Parisian Avant-Garde and the First World War*, Princeton University Press, New Jersey, 1989